Looking at Atget

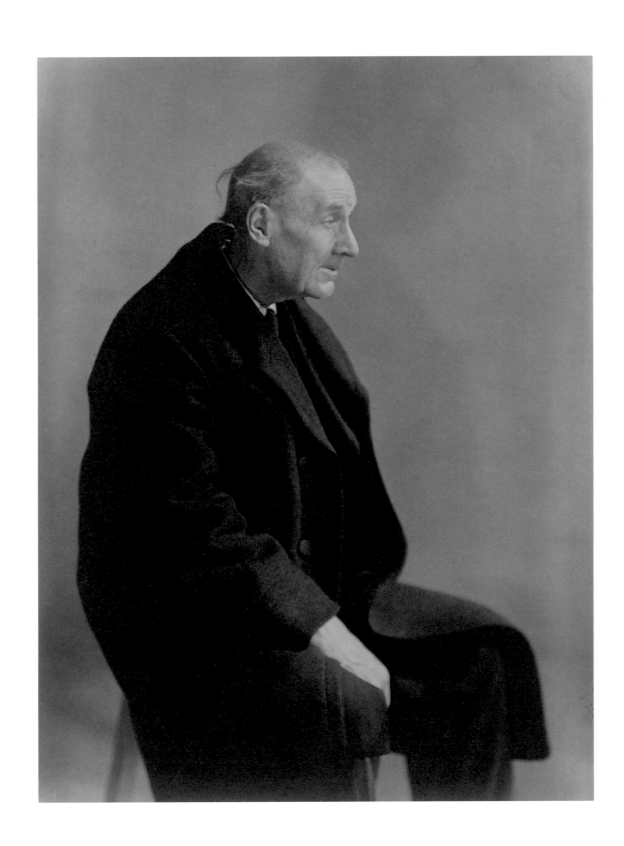

Looking at Atget

Peter Barberie

with an essay on the photographic materials by
Beth A. Price and Ken Sutherland

PHILADELPHIA MUSEUM OF ART
in association with
YALE UNIVERSITY PRESS
New Haven and London

Published on the occasion of the exhibition *Looking at Atget*, Philadelphia Museum of Art, September 10 to November 27, 2005.

The exhibition and catalogue were made possible by The Horace W. Goldsmith Foundation. The catalogue was also supported by an endowment for scholarly publications established at the Philadelphia Museum of Art in 2002 by The Andrew W. Mellon Foundation and matched by generous donors, and by a grant from The Andrew W. Mellon Foundation for the documentation of conservation projects.

Produced by the Publishing Department
Philadelphia Museum of Art
2525 Pennsylvania Avenue
Philadelphia, PA 19130 USA
www.philamuseum.org

Published by the Philadelphia Museum of Art in association with Yale University Press

Jacket front: Eugène Atget, *Versailles — Faun*, 1921–22 (fig. 92)
Jacket back: Eugène Atget, *Lily*, before 1900 or 1915–19 (fig. 115)

Frontispiece: Berenice Abbott, *Eugène Atget*, 1927. Gelatin silver print; image and sheet 9 1/16 x 6 3/4 inches (23 x 17.1 cm). Philadelphia Museum of Art. Gift of Mr. and Mrs. Carl Zigrosser, 1968-162-38
Page x: Eugène Atget, *Sign, rue Notre Dame de la Bonne Nouvelle*, 1904. Albumen silver print. Atget negative number 4834 (Art in Old Paris). Inscribed (by Abbott) on mount verso: *Enseigne — rue Notre Dame / de la Bonne Nouvelle / (1904)*. Philadelphia Museum of Art. The Lynne and Harold Honickman Gift of the Julien Levy Collection, 2001-62-79
Page 102: Detail of *Atget's Workroom* (fig. 18)

Edited by David Updike and Nicole Amoroso
Production by Richard Bonk
Designed by Dean Bornstein, Peacham, Vermont
Color separations, printing, and binding by Nissha Printing Co., Ltd., Kyoto, Japan

Text and compilation © 2005 Philadelphia Museum of Art
Figure 102 (p. 85) © Man Ray Trust / Artists Rights Society (ARS), New York / ADAGP, Paris

Library of Congress Cataloging-in-Publication Data

Barberie, Peter, 1970–
 Looking at Atget / Peter Barberie ; with an essay on the photographic materials by Beth A. Price and Ken Sutherland.
 p. cm.
 "Published on the occasion of the exhibition Looking at Atget, Philadelphia Museum of Art, September 10 to November 27, 2005."
 Includes bibliographical references and index.
 ISBN 0-87633-189-4 (PMA cloth) – ISBN 0-87633-190-8 (PMA paper) – ISBN 0-300-11137-1 (Yale cloth)
 1. Photography, Artistic — Exhibitions. 2. Atget, Eugène, 1857–1927 — Exhibitions. I. Atget, Eugène, 1857–1927. II. Price, Beth A. III. Sutherland, Ken, 1970– IV. Philadelphia Museum of Art. V. Title.
 TR647.A827B37 2005
 770'.92 — dc22
 2005004920

Contents

Foreword

In 2001, the Philadelphia Museum of Art became home to the Julien Levy Collection of photographs, through the extraordinary generosity of Levy's widow, Jean Farley Levy, and Lynne and Harold Honickman. Many treasures in this group of more than two thousand photographs were shown between 1931 and 1949 at Levy's New York gallery, where he established himself as a prescient and stalwart advocate of photographic art. Despite Levy's determination, the art-buying public was not yet prepared to collect the medium. As a result, Levy found himself with an incomparable cache of modernist photographs. Aside from an exceptional group of more than 250 photographs acquired by The Art Institute of Chicago, Mr. and Mrs. Levy's gift of thirty-one works to the Fogg Art Museum at Harvard University, and works sold privately and by the Witkin Gallery in New York, the collection remained in storage until Beth Gates Warren, Mrs. Levy's representative, contacted a trustee of the Museum.

Levy's collection of photographs is now one of the highlights of the Philadelphia Museum of Art, where it joins significant holdings of work by Levy's two adopted "intellectual godfathers," Alfred Stieglitz and Marcel Duchamp. The collection includes nearly all the photographers whose work Levy exhibited at his gallery and is a fascinating mix of pictures that reflects his varied and virtually unerring taste. Among them are familiar masterworks such as Charles Sheeler's *White Barn*, Manuel Alvarez Bravo's *Optical Parable*, and Man Ray's *Ciné Sketch*, as well as wonderfully fresh images by figures including André Kertész, Lee Miller, and Roger Parry. There are remarkable photographs by lesser-known artists and a delightful assortment of "found photographs" related to the spirit of Surrealist playfulness that animated the Julien Levy Gallery.

The centerpiece of the Levy Collection is a group of 361 works by Eugène Atget, some purchased in Paris from the artist and others acquired when Levy became Berenice Abbott's partner in preserving and promoting the contents of Atget's studio around 1930. Some of the images reflect Levy's avid engagement with Surrealism, while others give a broader picture of Atget and his enterprise, including prints from three of the photographer's paper albums, also in the collection. The holdings include four of Atget's glass-plate negatives, as well as a wonderful group of gelatin silver prints that Abbott made from Atget's negatives, demonstrating both her tremendous commitment to the artist and her determination to extend his work using completely different printing materials.

Levy's extensive collection of Atget photographs is shown here for the first time, offering an opportunity to consider Atget afresh, and also to explore Julien Levy's impact on photography in the twentieth century. Atget was Levy's "first" photographer, and the passion his work sparked led to a love for the medium whose greatest manifestation was the remarkable string of exhibitions at the Julien Levy Gallery between 1931 and 1949.

This exhibition and book would not have been possible without the support and generosity of The Horace W. Goldsmith Foundation, to which we extend our warmest thanks. Our great appreciation goes to Peter Barberie, the Museum's first Horace W. Goldsmith Curatorial Fellow in Photography, who organized the exhibition and wrote the engaging essay in this volume. We are grateful to P. Andrew Lins for his creation of the conservation science effort at the Museum, and to Beth A. Price and Ken Sutherland for contributing an informative essay summarizing their scientific examination of this trove of Atget photographs. We are indebted to The Andrew W. Mellon Foundation for its invaluable, long-term support of the Museum's mission to produce scholarly publications and to share its curators' and conservators' research with a wider audience. We remember with admiration and gratitude Jean Farley Levy, whose dedication to her husband and his reputation was absolute and whose efforts to bring Julien Levy's contributions to light inspire our own. Finally, we owe literally infinite thanks to Lynne and Harold Honickman, who immediately grasped the transformational difference the Julien Levy Collection would make to the important holdings of the Philadelphia Museum of Art in the field of photography, and whose generosity, together with Jean Farley Levy's, made this great acquisition possible for the Museum as a gift in honor of its 125th anniversary.

Anne d'Harnoncourt
The George D. Widener Director and Chief Executive Officer

Innis Howe Shoemaker
The Audrey and William H. Helfand
Senior Curator of Prints, Drawings, and Photographs

Katherine Ware
Curator of Photographs, Alfred Stieglitz Center

Acknowledgments

Any project of this size depends upon the expertise and generosity of colleagues and friends.

Innis Shoemaker, Dean Walker, Katherine Ware, and Andrew Lins at the Philadelphia Museum of Art shared their knowledge and made many thoughtful suggestions.

Museum paper conservators Nancy Ash, Faith Zieske, Scott Homolka, and Armelle Poyac treated a number of Atget's fragile prints, as did Barbara Lemmen at the Conservation Center for Art and Historic Artifacts in Philadelphia. There are thousands of Atget's prints in the world, and their preservation is of interest to many. Constance McCabe at the National Gallery of Art in Washington, D.C., Katherine Eremin at the National Museums of Scotland in Edinburgh, Boris Pretzel at the Victoria and Albert Museum in London, and Herant Khanjian at the Getty Conservation Institute in Los Angeles all shared their expertise on photography conservation and analysis.

Sherry Babbitt, Nicole Amoroso, David Updike, and Richard Bonk of the Museum's Publishing Department made the production of this book both a straightforward and an enjoyable project. They also made innumerable contributions to the structure and shape of the essays. Lynn Rosenthal and Joe Mikuliak expertly photographed the works of art. Dean Bornstein joined text and image to create the beautiful design for the book.

Our colleagues in Paris have shared their insights and provided access to the Atget photographs in their charge with generosity and hospitality. Our conversations with them have been among the real pleasures of working on this exhibition and catalogue. The authors warmly thank Sylvie Aubenas at the Bibliothèque Nationale; Anne Cartier-Bresson at the Atelier de Restauration et de Conservation des Photographies de la Ville de Paris; Laure de Margerie at the Musée d'Orsay; Anne de Mondenard at the Médiathèque de l'Architecture et du Patrimoine; and Françoise Reynaud and Catherine Tambrun at the Musée Carnavalet.

Atget's present-day American admirers, like his first ones, maintain an abiding commitment to his work. Molly Nesbit shared her research and her ideas about Atget's albums with inspiring candor. Sarah Hermanson Meister at The Museum of Modern Art was generous with her time and her knowledge about the Abbott-Levy collection of Atgets.

Marie Difilippantonio at the Julien Levy Archive has been a warm and enthusiastic friend to this project since its inception. Our thanks, too, to Eric Strom for helping bring the project to its fullest possible realization.

Other colleagues and friends have answered innumerable queries and assisted with research. For sharing their time and resources, we thank Debra Breslin, Peter Bunnell, Kate Bussard, Emily Glasser, Vivian Horan, Frank Kolodny, Peter Konin, Michelle Lamuniere, Thomas H. Lee, Steven W. Manford, Virgil Marti, Lilah Mittelstaedt, Faith Paffett-Lugassy, Courtney Shimoda, and Ann Tenenbaum.

A Note to the Reader

All of Eugène Atget's prints as well as Berenice Abbott's prints from his negatives are contact prints approximately equal in size to his glass-plate negatives, which measure 7¹⁄₁₆ x 9⁷⁄₁₆ inches (18 x 24 cm). Unless otherwise indicated, all prints reproduced here are in the collection of the Philadelphia Museum of Art. The Museum's Atget prints are illustrated to include the full sheet. The darkened edges on some prints indicate areas where the exposed sheet exceeded the negative. The numbers that appear in reverse in the corners of many prints are Atget's negative numbers, which he scratched into the emulsion on the negative.

The dates given for Atget's photographs are based on the dating chart in John Szarkowski and Maria Morris Hambourg, *The Work of Atget*, vol. 3, *The Ancien Régime* (New York: The Museum of Modern Art, 1983), pp. 181–83. The dates refer to the production of the negatives. Because Atget repeatedly printed from his negatives, it is not possible to precisely date the production of a particular print.

Unless otherwise indicated, all works reproduced are by Atget. The captions for Atget photographs reproduced in this book include both a title and an inscription (unless the print bears no inscription). Atget's own captions, typically inscribed on the verso of his prints, were descriptive and were not meant as titles; they sometimes vary from print to print for a given image. In the interest of providing the most information possible about a photograph, the titles used here are translations into English of the fullest Atget caption (or combination of captions) recorded. If Atget inscribed a caption on the verso of the print reproduced in this book, that inscription is included here, retaining Atget's errors and inconsistencies. When Abbott mounted Atget's prints and her prints from his negatives for exhibition, she typically inscribed captions onto the mount versos; her inscriptions are also recorded and are indicated as hers. The captions also include Atget's negative number for the photograph, followed in parentheses by the name of the series to which the number belongs.

Atget almost always inscribed a negative number on the verso of his prints, and Abbott usually transcribed that number onto the verso of her mounts. Moreover, Atget often stamped print versos, and Abbott almost always stamped mount versos. These marks and inscriptions have not been indicated in the captions here, but they are recorded in the Museum's cataloguing for each object.

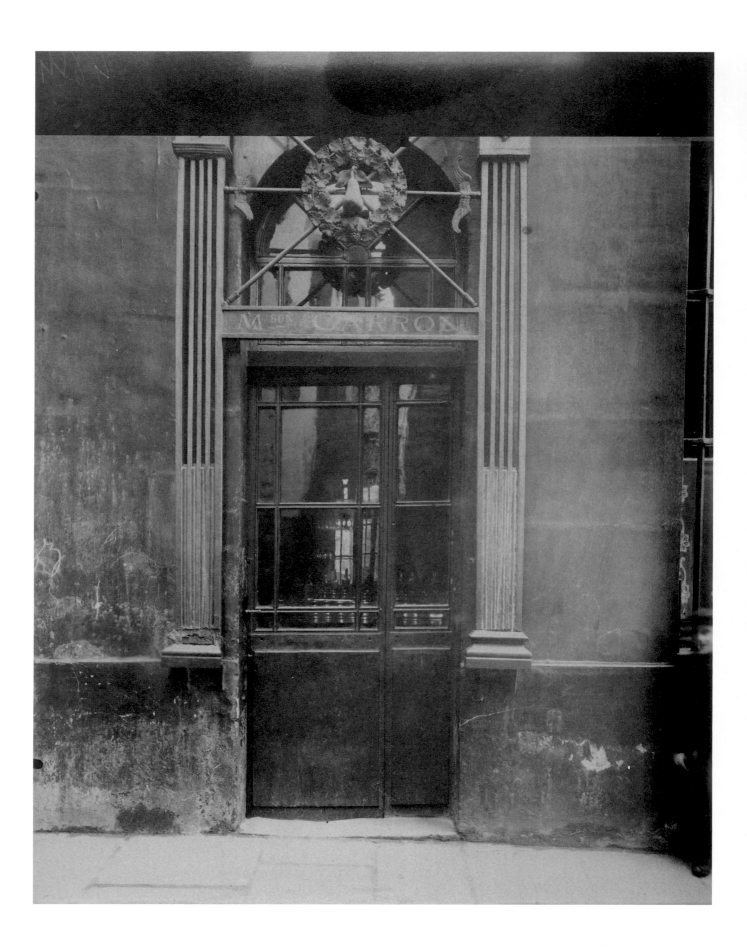

Looking at Atget

Peter Barberie

In looking at the work of Eugène Atget, a new world is opened up in the realm of creative expression as surely as the cotton gin awoke a sleepy world to the vista of industrialism, or the once forbidden tomato brought new delights to our palate.[1]

—Berenice Abbott, 1929

My photographs are giving me a heavenly summer...there is nothing I could ask for better than to roll myself between sheets of Atget, each new one I find (and there are thousands) is a revelation.[2]

—Julien Levy to Mina Loy, 1930

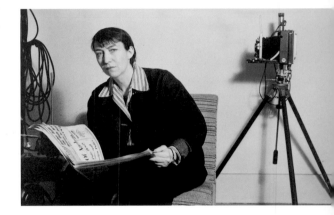

1. Arnold Newman (American, born 1918)
Berenice Abbott, 1944
Gelatin silver print; image and sheet 5¹⁵⁄₁₆ x 9⁹⁄₁₆ inches
(15.1 x 24.3 cm)
Gift of R. Sturgis and Marion B. F. Ingersoll, 1945-72-1

Tʜᴇsᴇ ᴛᴡᴏ sᴛᴀᴛᴇᴍᴇɴᴛs, brimming with passion and strange imagery, demonstrate the surprising enthusiasm for Eugène Atget's photography that spread in European and American art circles in the late 1920s. Today, the photographs of Atget (1857–1927), a commercial photographer in Paris from the 1890s until his death, form perhaps the most influential body of work made by a single photographer. The story of how the quiet career of this private man became central to the history of photography, and to modernist art, has been told several times.[3] This essay will revisit that story, with particular attention to the differing responses to Atget's work by two Americans, Berenice Abbott (1898–1991) and Julien Levy (1906–1981). Abbott (fig. 1), a Paris-based photographer from 1923 to 1929, and Levy (fig. 2), a young man soon to become a New York art dealer (he would open the Julien Levy Gallery in 1931), were both introduced to Atget's work in Paris in the mid-1920s by the Surrealist artist and photographer Man Ray (1890–1976), another American. But it was Abbott and Levy who brought Atget's photographs to an audience in the United States. After Atget's death in 1927 Abbott purchased the contents of his work-room—some 1,300 glass-plate negatives and 7,000 prints assembled in albums.[4] She brought the collection to New York in 1929 and by 1930 had enlisted Levy's silent financial backing; they both then promoted Atget's work through exhibitions and publications. Both were young, and both staked their future reputations to some degree on Atget's. The gambit paid. By the end of the 1930s, all

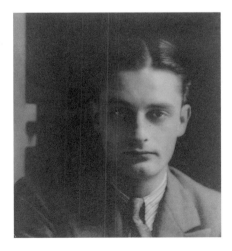

2. Berenice Abbott (American, 1898–1991)
Julien Levy, 1927
Gelatin silver print; image and sheet 7⅝ x 7 inches
(19.3 x 17.8 cm)
The Lynne and Harold Honickman Gift of the
Julien Levy Collection, 2001-62-4

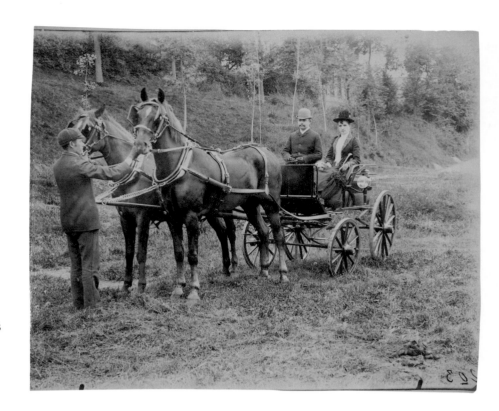

3. Untitled (Horse and Carriage with Couple),
before 1900
Albumen silver print. Atget negative number 203
(Landscape-Documents / Work Animals)
The Lynne and Harold Honickman Gift of the
Julien Levy Collection, 2001-62-2309

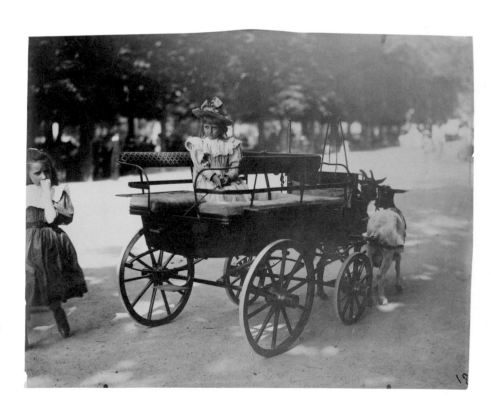

4. Untitled (Girl in Goat Cart), 1899–1900
Albumen silver print. Atget negative number 3181
(Picturesque Paris, Part I)
The Lynne and Harold Honickman Gift of the
Julien Levy Collection, 2001-62-309

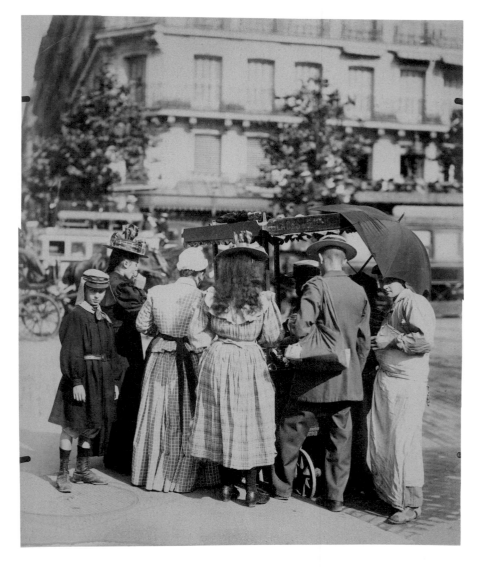

5. *Ice Cream Vendor, boulevard Saint-Michel,* 1898
Albumen silver print. Atget negative number 3180 (Pictur-
esque Paris, Part I)
Inscribed (by Abbott) on mount verso: *Rue Mouffetard* [sic]
The Lynne and Harold Honickman Gift of the Julien Levy
Collection, 2001-62-190

three had an American reputation, and Abbott and Levy had built successful
careers in their respective fields.

Atget took up photography around the age of thirty-five. A former touring
actor with his modest career behind him, he turned to his new craft to support
himself and his companion, Valentine Compagnon, who was herself an actress.
For more than thirty years Atget made photographs for sale—first, studies of
trees and animals and scenery for artists, and then, increasingly, scenes of street
life in the city and records of shop displays, architecture, art, and gardens (figs.
3–12). He sold these photographs not only to artists but to all sorts of design-
ers, such as cartoonists, stage set designers, decorators—in short, any type of
artisan who might use an image of a flower, a tree branch, a courtyard, a car-
riage for the purposes of his or her own trade. But Atget found his greatest
business with antiquarians, architects, and libraries, all of whom sought visual
documents of the artistry and buildings in Paris and its environs, and many of
whom bought whole groups of his photographs at a time.

Atget made at least eight to ten thousand different photographs during his

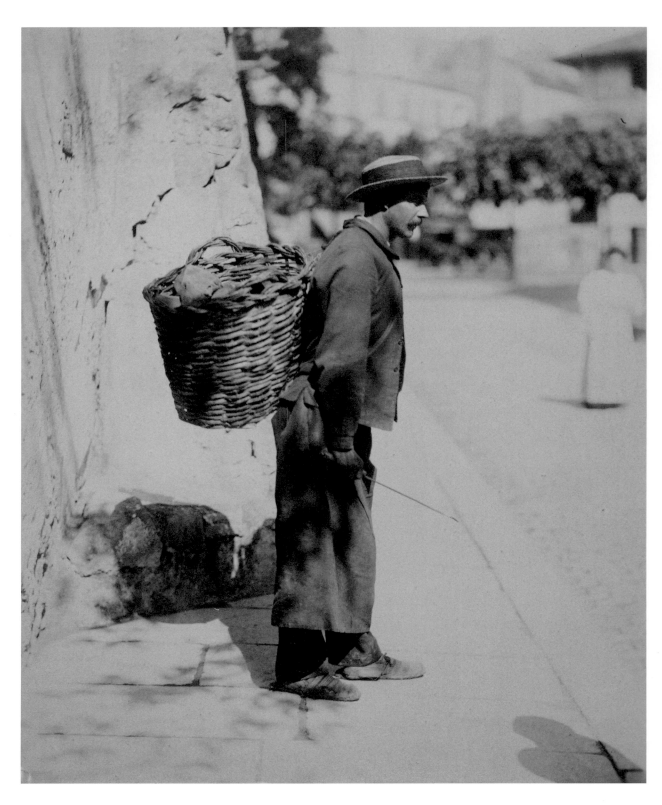

6. *Ragpicker*, c. 1898–1900
Albumen silver print. Atget negative number undetermined
Inscribed (by Abbott) on mount verso: *Chiffonier*
The Lynne and Harold Honickman Gift of the Julien Levy Collection, 2001-62-71

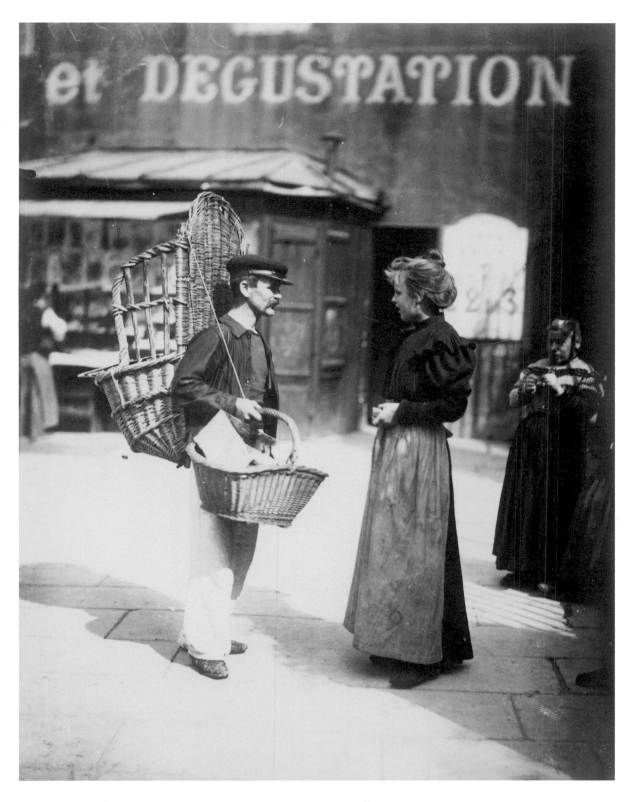

7. *Basketseller, rue Mouffetard,* 1899–1900. Printed by Berenice Abbott, c. 1930
Gelatin silver print. Atget negative number 3194 (Picturesque Paris, Part I)
Inscribed (by Abbott) on mount verso: *Marchand au Panier*
Gift of Mr. and Mrs. Carl Zigrosser, 1968-162-35

8. Untitled (Kiosk), 1898–99
Albumen silver print. Atget negative number
3129 (Picturesque Paris, Part I)
The Lynne and Harold Honickman Gift of the
Julien Levy Collection, 2001-62-308

FACING PAGE:
9. *Courtyard, Church of Saints-Gervais-et-
Protais*, 1899–1900
Gelatin silver chloride print. Atget negative
number 3751 (Art in Old Paris)
Inscribed (by Abbott) on mount verso: *Cour St.
Gervais et Protais*
Gift of Mr. and Mrs. Carl Zigrosser, 1968-162-32

career, and he sold many thousands of prints from his negatives. Today, more than twenty thousand of his prints remain. He always worked alone, traveling throughout Paris and the Île-de-France to expose his negatives, and then printing them in a workroom in his apartment, in the artists' neighborhood of Montparnasse. He sometimes sold his prints through booksellers or other intermediaries, but most of the time Atget sold the photographs himself, calling on clients who might buy large groups of pictures and receiving artists and other small buyers in his workroom.

Atget's photography is remarkable for the scope and depth of its subject matter, but his career was similar to those of dozens of other photographers who worked in Paris during his lifetime. The parameters of his trade, like his life, were modest. Yet Atget took his work most seriously. His photographs manifest a daunting ambition to record countless things. What is more, he made these documents with what can only be called a particular sensibility—his photographs often depart from the familiar conventions of photographic records

10. *Austrian Embassy, 57, rue de Varenne*, 1905
Albumen silver print. Atget negative number 5111
(Art in Old Paris)
Inscribed on verso: *Ambassade d'autriche / 51* [sic]
Rue de Varenne
The Lynne and Harold Honickman Gift of the
Julien Levy Collection, 2001-62-49

(although they answer the criteria for such records very well). And Atget went to considerable effort to sell them to libraries and museums, where he knew they might remain for a long time.[5] We have no reason to think Atget looked at his photographs with modern art in mind, but he probably hoped they would make compelling history.

Atget's admirers in the 1920s loved his work for reasons of their own. Although Abbott and Levy jointly owned Abbott's large Atget collection and shared an abiding passion for his legacy, they treated that legacy differently. Abbott promoted Atget as a great "styleless" photographer who recorded the world around him with humility and respect for his subjects. In 1941 she wrote, "He did not veer toward excessive concern with technic [sic] nor toward the imitation of painting but steered a straight course, making the medium speak for itself in a superb rendering of materials, textures, surfaces, details."[6] By

contrast, Levy was one of the few connoisseurs of photography in the 1920s and 1930s, which is to say he was among a handful of collectors and curators who treated the medium as a serious art form. Levy was also, and above all, an advocate of Surrealism, not simply as a literary and artistic movement but as a mode of being in the world, and he remained so until the end of his life. Like Man Ray, Levy saw in Atget a proto-Surrealist.

In 1969 Abbott and Levy sold to the Museum of Modern Art in New York the collection of Atget prints and negatives that Abbott had purchased and preserved for forty years. Levy, however, retained his personal collection of Atget photographs, which he had built separately from the jointly owned collection by purchasing prints directly from Atget and from other sources. He certainly acquired part of this group from Abbott, including her own prints from Atget negatives, three of the paper albums Atget had made to hold his prints, and four of his glass negatives. Ever the dealer, Levy sold an unknown number of the Atget photographs in his later years.[7] Today, 361 works from Levy's holdings form the bulk of the Philadelphia Museum of Art's Atget collection, which offers three distinct views of Atget's photography: that of Atget himself, who assembled the three paper albums, which Levy acquired still laden with prints, for his workroom stock; that of Abbott, who, around 1930, printed certain works that she felt exemplified Atget's objective style and purpose; and that of Levy, who collected the photographs with the self-consciousness of an aspiring Surrealist and—not unrelated—the very personal choices of a collector-*amateur*.

In his 1973 book *Looking at Photographs*, the critic and historian John Szarkowski writes: "[I]t is somehow unsatisfactory to sum up in half a dozen prints the meaning of the life's work of an Atget or a Stieglitz or a Weston. Although such a selection might represent the basic visual ideas that were explored throughout a lifetime, the process of abstracting to so economical a core seems inimical to the spirit of photography, which is generous and fecund, and which delights in the inexhaustibly various guises in which a single idea will reveal itself."[8] Szarkowski's exhortation to look at many photographs is a leading note for this exploration of Atget. It is also a point of departure.

For Szarkowski, Atget's work, despite its fecundity, is indeed informed by one overriding "visual idea": a boundless document of French civilization extended in each photograph.[9] That is an appealing way to account for Atget's enormous output, but this photographer did not pursue a comprehensive single idea, or even a set of related ideas, in all his work. Atget made his photographs to satisfy the precise interests of numerous clients.[10] When we consider the photographs altogether, there are numerous things to say about them, and none applies very well to the whole. They require many looks and several modes of looking. Some of Atget's prints are finely crafted, elegant things. Most are not. They are serviceable documents with a variety of flaws and, incidentally, quite uneven edges. The same is true of his photographic compositions. Atget composed to document information; the overall unity of a picture was evidently often irrelevant to him. In many of his photographs, the negative clips and lens barrel of his camera figure into the picture along with whatever subject he had in view (see fig. 22). And yet, Atget's compositions are stunning. He twinned shapes and motifs (see figs. 58, 59); he created strange conjunctions of

11. *Grocery-Bar, boulevard Masséna,* 1912
Matte albumen silver print, Atget negative number 366 (Picturesque Paris, Part II)
Inscribed on verso: *Bd. Masséna*
The Lynne and Harold Honickman Gift of the Julien Levy Collection, 2001-62-46

12. *Grocery-Bar, boulevard Masséna,* 1912
Gelatin silver chloride print. Atget negative number 367 (Picturesque Paris, Part II)
Inscribed on verso: *Bd. Masséna*
The Lynne and Harold Honickman Gift of the Julien Levy Collection, 2001-62-59

foreground and distance (see fig. 55); he employed the inherent distancing of the camera to confer an otherworldliness on whole scenes (figs. 13, 14).

If we turn to his subjects, Atget sometimes pursued a topic with single-minded purpose. The photographs he made of various domestic interiors in 1910 (see figs. 25–49) are a remarkable example. But in other instances, the many photographs Atget made of a motif have little to do with one another in terms of style or function. His photographs of parks like Versailles and the Tuileries, made throughout his career, demonstrate such diverseness in the kinds of information they record and the corresponding ways in which Atget composed them.

Atget made his photographs as various kinds of documentation, but many of his critics have transposed his work to the register of modernist art. That leap opens up inconsistencies between the nature of the work and the words written about it, but it has also resulted in a dilemma over how to look at the pictures in a way that somehow suits them. Today, we have many Atgets and several compelling arguments for how to view them. Since the Philadelphia Museum of Art's collection of Atgets is intimately connected to the career and ideas of Levy, as well as those of Abbott and Atget himself, it is fruitful to discuss the photographs as a collection informed by these viewpoints.[11] So this story of looking at Atget is one of looking at the particular Atgets in the Philadelphia Museum of Art in the configurations by which they have come to us: organized by Atget in albums, promoted by Abbott, collected by Levy.

The Photographer and His Many Pictures

Fairly early in his career Atget developed an idiosyncratic numbering system to keep track of all of his images. Over time he devised five main sets of numbers, or series, each of which contained a thousand or more images, and about eight subsidiary series, which comprised anywhere from a few dozen to hundreds of images.[12] Generally the series corresponded to distinct categories of subjects, although some subjects found their way into multiple series (the park of Versailles, which Atget photographed frequently over a twenty-five-year period, appears in three series: Environs, Landscape-Documents, and Versailles). Moreover, Atget sometimes changed a photograph's number and consequently its series, reinserting it in a newer vein of his work where it served a somewhat different purpose and took on different resonance. Atget typically scratched a picture's number into the emulsion on a corner of the negative, and he inscribed the same number in graphite on the backs of prints made from that negative. Atget always used 18 x 24 centimeter (7⅟₁₆ x 9⁷⁄₁₆ inch) glass-plate negatives (see fig. 116). The photographs he made from them were always contact prints, or prints the same size as the negative, and he always printed them out, meaning that he did not develop the images with photographic chemicals, but rather exposed the paper through the negative until the full image appeared.

Most of Atget's photographs are albumen silver prints, made on very thin paper and characterized by their remarkable clarity in relation to other early photographs. The albumen process was standard in the nineteenth century for photographic prints, especially document photographs. Despite the fact that albumen prints were becoming obsolete at the beginning of Atget's career, he

13. *Petit Trianon*, 1921–22
Albumen silver print. Atget negative number 1077
(Versailles or Landscape-Documents / Mixed
Documents)
Inscribed on verso: *Petit Trianon*
The Lynne and Harold Honickman Gift of the
Julien Levy Collection, 2001-62-183

14. *Grand Trianon — Temple of Love*, 1922–23
Matte albumen silver print. Atget negative number
1164 (Versailles or Landscape-Documents /
Mixed Documents)
Inscribed on verso: *Gd Trianon (Temple de l'Amour)*
The Lynne and Harold Honickman Gift of the
Julien Levy Collection, 2001-62-200

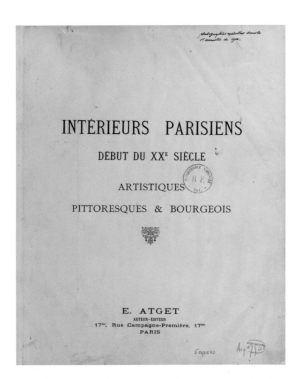

15. Title page to Eugène Atget, *Intérieurs Parisiens Début du XXᵉ Siècle, Artistiques, Pittoresques & Bourgeois* (Paris, 1910)

preferred them, perhaps because the process allowed for great control over the final appearance of a photograph, permitting, for example, a range of nuances in the middle tones of a print (see figs. 53, 54). Atget made albumen silver prints until the end of his life. He also made three other types of prints: matte albumen prints, which combine a starch compound with the light-sensitive materials and produce a velvety picture surface that is aesthetically pleasing but not always ideal for photographic records; gelatin silver chloride prints, which have a similar gloss and comparable clarity to albumen prints but are less delicate; and matte gelatin silver chloride prints, which Atget made least often, perhaps only to compare with the scumbled surface of matte albumen prints.[13] Atget seems never to have nuanced the chemistry of the gelatin silver chloride process, judging from the number of errors evident in those prints. He may have turned to the alternative processes when it became difficult to secure albumen papers during and after World War I. However, Atget printed from his various negatives continuously (as duplicate prints in different processes in the Museum's collection attest), so it is difficult to surmise precisely when or why he used one printing process or another. All of his prints, whatever the process, are darker and better preserved when they contain higher amounts of gold toning, a standard means for stabilizing and enriching prints during Atget's career.

Atget's mode was the album. Whenever he organized his prints, whether filing them for his workroom stock, gathering them together to show clients, or preparing finished projects to deposit in libraries, he used albums (figs. 15–17). These three purposes resulted in three distinct types of album, and each type informed Atget's thinking about the others. It is fair to say that the general format of an album—the ordered presentation of a group of images—was basic to Atget's thinking about his photographs as a whole.[14] All of his albums depend on the relationship of one image to another in order to make sense of the overall grouping. The organizational idea behind a given album might be

16. *Album No. 1, Jardin des Tuileries*, 1900–1927
Paper album folder with paper leaves, 10⁷⁄₁₆ x 8⅞ inches (26.5 x 22.5 cm)
The Lynne and Harold Honickman Gift of the Julien Levy Collection, 2001-62-45

17. *Intérieurs Parisiens Commencement de 20ᵉᵐᵉ Scle, Artistiques, Pittoresques & Bourgeois, Album No. 1*, 1910
Paper album folder with paper leaves, 11⁵⁄₁₆ x 9⅛ inches (30.2 x 23.2 cm)
The Lynne and Harold Honickman Gift of the Julien Levy Collection, 2001-62-2518

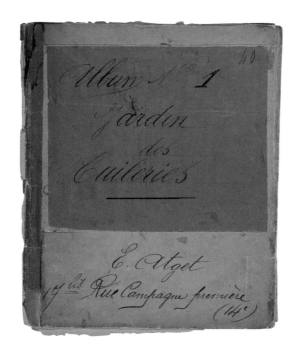

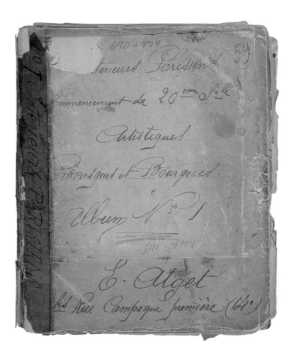

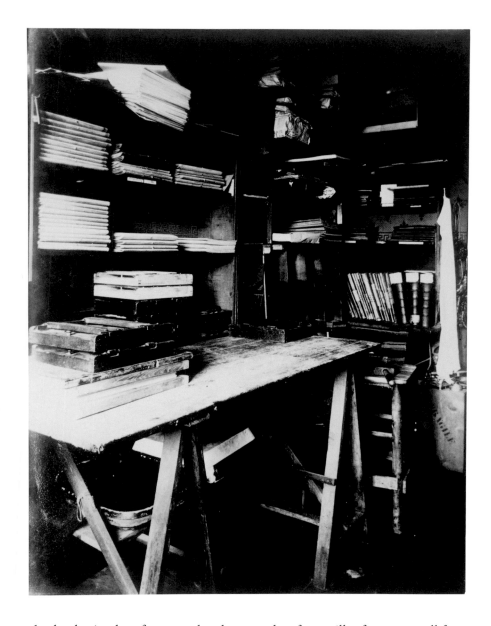

18. *Atget's Workroom*, 1910–11
Printed by Berenice Abbott, c. 1930
Gelatin silver print. Atget negative number 251
(Picturesque Paris, Part II)
Inscribed (by Abbott) on mount verso: *Intérieur Atget*
Gift of Mr. and Mrs. Carl Zigrosser, 1968-162-33

absolutely simple — for example, photographs of Versailles from 1904, all from the Environs series, organized by negative number for easy retrieval in Atget's workroom (fig. 18). Or it might be somewhat more specific, if equally straightforward — for example, photographs of eighteenth-century Paris mansions, also stored in a simple paper album, but organized by building and neighborhood for a compelling presentation to the designers and antiquarians who might want them. Atget would take this kind of album on his visits to clients and use it something like a salesman's sample book, probably selling prints right out of the album and then printing replacements when he returned to his workroom.[15] In the case of the albums Atget put together for deposit as finished books in Paris libraries, the organization is layered and complex and amounts to a visual essay whose argument is built picture by picture, page by page. A supreme example of this is his album of domestic interiors from 1910, titled *Intérieurs Parisiens Début du XXᵉ Siècle, Artistiques, Pittoresques & Bourgeois* (see fig. 15). The photographs purport to represent twelve different apartments in Paris, inhabited

19. *Tuileries Gardens,* 1907–8
Albumen silver print. Atget nega-
tive number 5485 (Art in Old Paris)
Inscribed on verso: *Tuileries*
The Lynne and Harold Honickman
Gift of the Julien Levy Collection,
2001-62-225

by people of diverse circumstances. In the album the pictures are organized by apartment, but some apartments are featured twice, as two different addresses. Moreover, Atget veiled the identities of the dwellings' inhabitants; the titles of the photographs include only the owner's initial, occupation, and street. The result of the album's careful groupings and matter-of-fact captions is a breath-taking document of interior design, personal space, and socioeconomic class in 1910 Paris.[16]

The three Atget albums in the Julien Levy Collection at the Philadelphia Museum of Art are all simple paper storage albums, crafted by the photographer himself. Atget kept dozens of such albums in his workroom. Today, those that remain are crumbling into dust, but they offer a remarkable view of Atget's working methods with his photographs. All three albums at the Museum held park photographs, but apart from that common thread they are quite different. The most complete album is another version of the interiors album described above (see fig. 17). It held the same photographs, but because it was made for the workroom, they were ordered consecutively by negative number rather than in Atget's carefully grouped juxtapositions. Atget kept prints of most of his images on hand in the workroom, and he often frugally recycled his albums

for them, repapering the covers with new title sheets and sometimes storing two or three groups of images together. The interiors workroom album, for example, originally held Versailles photographs made in 1904 for the Environs series. In 1910, when he was assembling the interior photographs, Atget left the Versailles prints in the album and merely inserted the interior prints into alternating page spreads, erasing and reinscribing pages as necessary. When Julien Levy acquired the album, it contained prints from both series, sometimes two or three of a given image. And so photographs from two unrelated series lived together, like plants in an overgrown garden — overgrown, but well tended: any print could be retrieved in a moment.

The Museum's two other albums are both fragmentary. *Album No. 1, Jardin des Tuileries* has only four of its pages remaining (see fig. 16), but it seems to have comprised photographs of the Tuileries Gardens made between 1902 and 1908 for Atget's Art in Old Paris series (fig. 19). The other album lacks its cover and title, but it contained photographs of numerous Paris parks, including the Tuileries, made for at least three series between 1905 and 1923. It is a good example of Atget's second type of working album, organized not by consecutive number for reference but by subject, and geared toward one segment or another

20. *Palais Royal*, 1909 or 1913–14
Albumen silver print. Atget negative number 486 (Topography or Picturesque Paris, Part II)
Inscribed on verso: *Palais Royal*
The Lynne and Harold Honickman Gift of the Julien Levy Collection, 2001-62-172

21. *Parc Monceau*, 1921
Albumen silver print. Atget negative number 1069 (Landscape-Documents / Mixed Documents)
Inscribed on verso: *Parc Monceau*
The Lynne and Harold Honickman Gift of the Julien Levy Collection, 2001-62-178

22. *Parc Montsouris — Plane Trees*, 1923
Albumen silver print. Atget negative number 11 (Paris Parks)
Inscribed on verso: *Parc Montsouris / Platanes*
Purchased with the Lola Downin Peck Fund, the Alice Newton Osborn Fund,
other Museum funds, and with the partial gift of Eric W. Strom, 2004-110-19

of his clientele. This album included photographs of public places such as the
the Palais Royal (fig. 20), the Parc Monceau (fig. 21), and the Parc Montsouris
(fig. 22), but also quasi-private gardens such as the one at the Austrian Embassy
(fig. 23).[17] Atget returned to his park subjects with renewed focus in the 1920s,
and those photographs constitute at least a quarter of the 1,600 or so new pic-
tures he made in those years. This volume of production led him to start four
new series—three of the royal parks of Versailles (1922), Saint-Cloud (1922;
fig. 24), and Sceaux (1925; see fig. 114), and another smaller series called sim-
ply Paris Parks (1923). The Museum's fragmentary album of Paris parks, with
eighteen years' worth of disparate prints gathered for presentation to clients, is
a relic of that renewed attention.

23. *Austrian Embassy, 57, rue de Varenne,* 1905
Albumen silver print. Atget negative number 5108 (Art in Old Paris)
Inscribed on verso: *Ambassade d'autriche*
The Lynne and Harold Honickman Gift of the Julien Levy Collection, 2001-62-52

24. *Saint-Cloud*, 1922–23
Albumen silver print. Atget negative number 1188 (Saint-Cloud)
Inscribed on verso: *St Cloud*
The Lynne and Harold Honickman Gift of the Julien Levy Collection, 2001-62-193

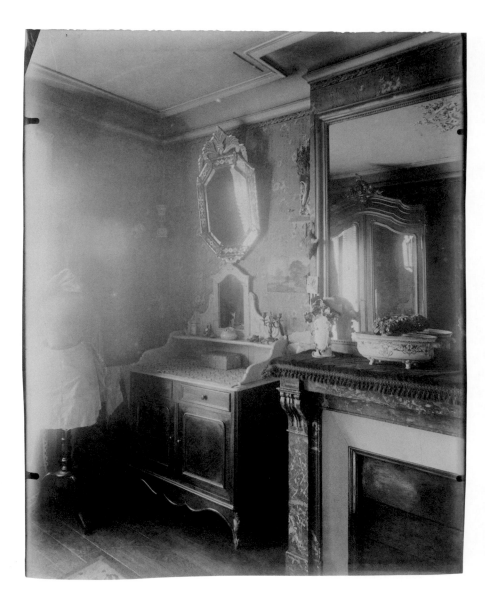

25. Untitled (Interior of an Employee of the Magasins du Louvre, rue Saint-Jacques), 1909–10
Albumen silver print. Atget negative number 724 (Interiors)
The Lynne and Harold Honickman Gift of the Julien Levy Collection, 2001-62-299

The Interiors Album

The Museum's interiors album encapsulates the cross-fertilization between the various kinds of album with which Atget worked. Leaving aside for the moment the 1904 Versailles photographs it contained, the album served as a storage unit for prints from the Interiors series and a workbook of sorts where Atget formulated his ideas for the finished, public version of the album. This public version exists in three copies. Atget made all the photographs in 1909 and 1910, and by 1911 he had sold his carefully composed arrangement of them to three institutions, all regular clients of his: the Bibliothèque Nationale, the Musée Carnavalet, and the Bibliothèque Historique de la Ville de Paris. These institutions all collect documents of the history of Paris, and Atget's comparative views of Parisian homes fit that purpose. Although the interior photographs were unlike Atget's typical wares, his institutional clients would have been less concerned about their precise contents than more

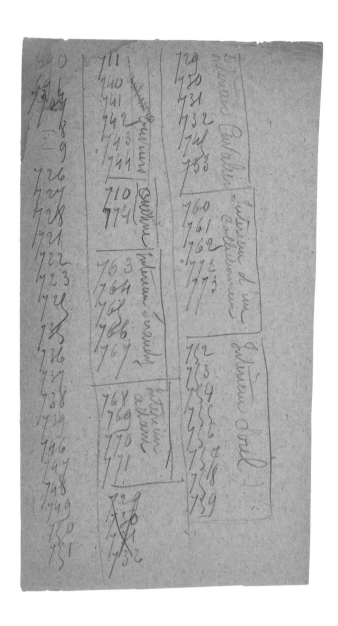

26. Worksheet from *Intérieurs Parisiens Commencement de 20ᵉᵐᵉ Scle, Artistiques, Pittoresques & Bourgeois, Album No. 1.* 9⅝ x 5 inches (24.4 x 12.7 cm)
The Lynne and Harold Honickman Gift of the Julien Levy Collection, 2001-62-2518

specialized buyers of his photographs. Only the Bibliothèque Nationale bought a bound album with the printed title page Atget designed for it (see fig. 15). The Musée Carnavalet bought the ensemble in one of Atget's paper albums with the title page pasted on its cover, and the Bibliothèque Historique de la Ville de Paris bought the photographs individually mounted to cardboard sheets for easy placement in the library's *moeurs* files, where they served as documents of customs.[18]

As stated above, in the Museum's album the interior photographs are simply filed in order by the series negative number. This workroom album has one photograph that Atget eliminated from the public version, an additional view of one of the bedrooms (fig. 25). The album also contains a loose worksheet on which Atget wrote the negative numbers, drawing boxes around groups of them to organize them into schematic arrangements (fig. 26). The ordering of the numbers on this sheet closely matches the groupings of photographs in the public album, and it is clear that Atget used the sheet and the open workroom

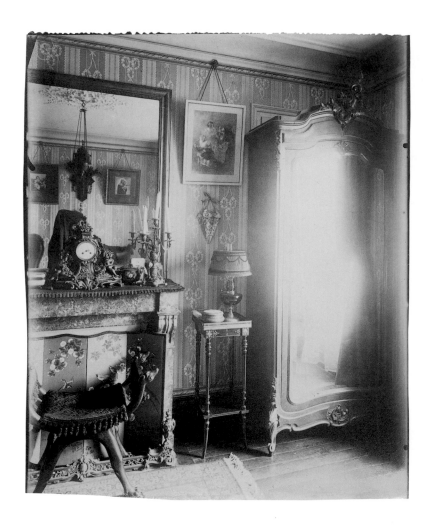

27. *Interior of Madame D., Woman with a Small Private Income, boulevard du Port Royal,* 1909–10
Albumen silver print. Atget negative number 709
(Interiors)
Inscribed on verso: *Intérieur de Mme. Dubois / rentière Bd. du Port Royal*
The Lynne and Harold Honickman Gift of the Julien Levy Collection, 2001-62-105

album to put the interior photographs into the narrative "chapters" they form in the public version. Inscriptions in the workroom album—both on the worksheet and on pages designated for specific photographs—confirm what Atget scholars Maria Morris Hambourg and Molly Nesbit have written about these photographs: he photographed ten homes, his own and nine others. From those photographs he invented twelve "interiors" for the public album—three of them fictional. (In the public album he distributed the photographs of his own apartment among three residences, further weaving artifice into the whole.) In his workroom album Atget dispensed with disguise, identifying the interiors by the following names, addresses, and occupations (in order of appearance): Dubois, in the boulevard du Port Royal (figs. 27, 28); Rufel, in the rue Saint-Jacques (see figs. 25, 30); Féraudy, in the rue Montaigne (see figs. 35, 36); a milliner, unnamed, at the place Saint-André-des-Arts (see fig. 32); Adam, in the rue Lepic (fig. 29); Monot, financier, in the avenue Elisée Reclus (see fig. 31); a laborer, unnamed, in the rue de Romainville (whom we presume to be one Léon Morat, from the lifesaving diplomas adorning the bedroom wall; see figs. 41–43); Cavalier, in the rue du Montparnasse (see figs. 44, 45); and Mlle. Sorel of the Comédie Française, at 99, avenue des Champs-Elysées (see figs. 33, 34, 39). Atget placed his own name on the album pages designated for scenes of his own quarters (see figs. 46–49).

 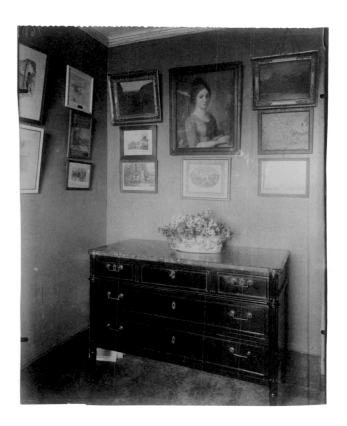

28. *Interior of Madame D., Woman with a Small Private Income,*
boulevard du Port Royal, 1909–10
Albumen silver print. Atget negative number 727 (Interiors)
Inscribed on verso: *Int. Dubois*
The Lynne and Harold Honickman Gift of the Julien Levy Collection,
2001-62-106

29. *Interior of Monsieur A., Industrialist, rue Lepic,* 1910
Albumen silver print. Atget negative number 768 (Interiors)
Inscribed on verso: *Interieur / Adam*
The Lynne and Harold Honickman Gift of the Julien Levy Collection,
2001-62-91

The workroom album of interiors, with its worksheet and revealing inscriptions, permits us to read personal anecdote into the photographs. And anecdotal questions are somehow germane to these images, even though they are impossible to answer, and even though Atget wrote them out of the picture, as it were, when he paired the photographs with his mostly anonymous, strictly comparative captions in the public album. Who were these people, and how did Atget gain intimate access to their homes? It is remarkable, for example, that Atget photographed each of his subjects' beds (figs. 30–32), except Adam's and his own. Most personal accounts of Atget paint him as a notably private man.[19] Yet for his Interiors series, he persuaded nine people to grant him a more personal view of their lives than he perhaps ever offered of his own. In the case of Cécile Sorel, the one subject whose identity Atget did not conceal in any album, this is easy to understand. Sorel was a famous actress and a high-profile collector of eighteenth-century antiques; her home was photographed more than once and served as another stage for her public life (figs. 33, 34).[20] Atget need not have known her well to gain access to her home, and it is likely he or his companion, Valentine Compagnon, found connections to the actress through their friends in the theater world. The same might be true of another famous actor of the day, Maurice de Féraudy, whose home, perhaps, is the one represented by Atget as that of a *négociant* (merchant) in some photographs or an *agent de change*

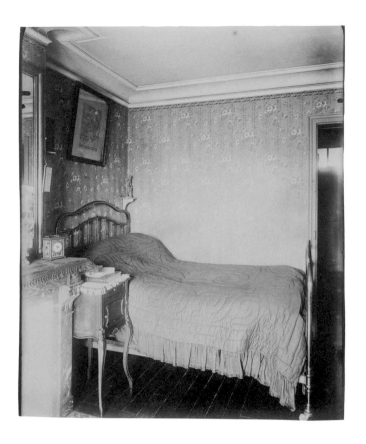

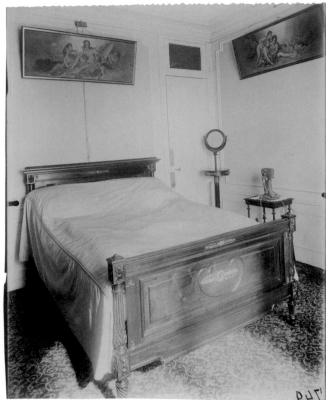

CLOCKWISE:

30. *Interior of an Employee of the Magasins du Louvre, rue Saint-Jacques*, 1909–10
Albumen silver print. Atget negative number 725 (Interiors)
The Lynne and Harold Honickman Gift of the Julien Levy Collection, 2001-62-289

31. *Interior of Monsieur M., Financier, avenue Elisée Reclus, Champ de Mars*, 1910
Albumen silver print. Atget negative number 749 (Interiors)
Inscribed on verso: *M. M. Financier / Avenue Elisée Reclus*
The Lynne and Harold Honickman Gift of the Julien Levy Collection, 2001-62-162

32. *Interior of Madame C., Milliner, place Saint-André-des-Arts*, 1909–10
Albumen silver print. Atget negative number 736 (Interiors)
Inscribed on verso: *Interieur d'une / Modiste*
The Lynne and Harold Honickman Gift of the Julien Levy Collection, 2001-62-94

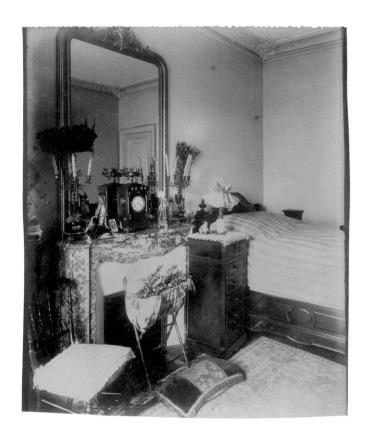

33. *Interior of Mademoiselle Sorel of the Comédie Française, 99, avenue des Champs-Elysées,* 1910
Albumen silver print. Atget negative number 752 (Interiors)
Inscribed on verso: *Intérieur de Melle. Sorel de / la Comedie Francaise—99 / Avenue des champs Elysées*
The Lynne and Harold Honickman Gift of the Julien Levy Collection, 2001-62-110

34. *Interior of Mademoiselle Sorel of the Comédie Française, 99, avenue des Champs-Elysées,* 1910
Albumen silver print. Atget negative number 753 (Interiors)
Inscribed on verso: *Interieur Sorel*
The Lynne and Harold Honickman Gift of the Julien Levy Collection, 2001-62-109

35. *Interior of Monsieur F., Merchant, rue Montaigne,* 1910
Albumen silver print. Atget negative number 764 (Interiors)
Inscribed on verso: *Intérieur de M. F / Rue Montaigne*
The Lynne and Harold Honickman Gift of the Julien Levy
Collection, 2001-62-102

36. *Interior of Monsieur F., Merchant, rue Montaigne — Atelier
of Madame, Amateur Sculptor,* 1910
Albumen silver print. Atget negative number 767 (Interiors)
Inscribed on verso: *Interieur de M. F / négociant Rue / Montaigne*
The Lynne and Harold Honickman Gift of the Julien Levy
Collection, 2001-62-101

(stockbroker) in others (figs. 35, 36). Atget and Féraudy had studied together as young men at the prestigious National Conservatory of Music and Drama.[21] It is possible they remained friendly, or at least acquainted, despite the gap in fame and status between them. Although there is no known record linking Maurice de Féraudy to the rue Montaigne address, de Féraudy is an aristocratic name and has a correspondingly small number of owners. If the home depicted is not his, it is possible nonetheless that he effected Atget's introduction to the household.

It is likely that all the apartments Atget photographed for this series belonged to friends or acquaintances. We know a little bit more about the Féraudy household than the others. A sculptor, Berthe de Féraudy, rented quarters at 14 bis, rue Montaigne.[22] The studio, and probably some of the statues seen in other rooms, are hers. We do not know Madame de Féraudy's connection to the actor Maurice de Féraudy, but we do know she advertised her wares and her address in the *Bottin*, the Paris directory roughly equivalent to a phone book, designed to serve merchants and their clientele.[23] If one were not in business, or if one's business were very grand or very modest (a financier or a laborer), there was no point to a listing. Unfortunately, most of Atget's other subjects lived their lives outside the *Bottin* and remain mysterious to us. We do find M. Cavalier, the decorator, in the *Bottin*, at 25, rue du Montparnasse. However, his name

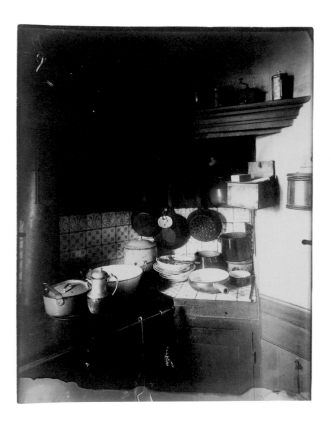

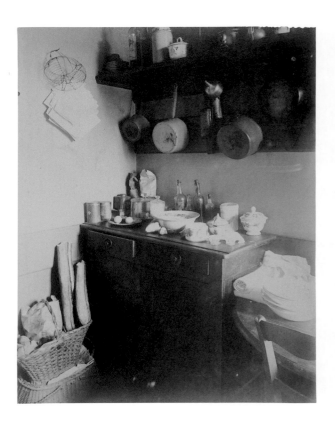

37. *Interior of Monsieur F., Merchant, rue Montaigne — The Kitchen*, 1910
Matte albumen silver print. Atget negative number 774 (Interiors)
Inscribed on verso: *Cuisine*
The Lynne and Harold Honickman Gift of the Julien Levy Collection, 2001-62-76

38. *Interior of Monsieur F., Merchant, rue Montaigne — The Kitchen*, 1909–10
Albumen silver print. Atget negative number 710 (Interiors)
Inscribed (by Abbott) on mount verso: *Interieur*
The Lynne and Harold Honickman Gift of the Julien Levy Collection, 2001-62-89

was actually Cavaillé-Coll, and he listed himself as *peintre-décorateur* (painter-decorator). Atget misrecorded the name in his *répertoire*, or address book of clients and contacts, just as he did in the workroom album, so we can be quite sure it is Cavaillé-Coll's rooms that are depicted here.[24]

The Museum's workroom album of interiors does contain a few of the fictions Atget introduced into the public album. As noted, in the workroom album Atget inscribed his own name on the pages that held scenes of his apartment, yet there is one exception. On a single page he inscribed a fictional identity that also made its way into the public album: "interior of a dramatic artist, rue Vavin." Atget had been a dramatic artist, and Valentine Compagnon no doubt still considered herself one. However, they lived at 17 bis, rue Campagne-Première. The rue Vavin was in their neighborhood, a little bit closer to the Luxembourg Gardens, in the more elegant sixth arrondissement. Another inscription relating to their apartment might also be feigned. The last photograph in the series, a view of Atget's kitchen, is identified as such in the workroom album (fig. 37). But an earlier kitchen photograph, whose order in the numbering indicates it too is a view of Atget and Compagnon's home, is labeled as the kitchen in the rue Montaigne (fig. 38). In the public version of the album, both kitchen views are given to Monsieur F., *négociant*.

Nesbit has catalogued the uses Atget and others made of his photographs.

39. *Interior of Mademoiselle Sorel of the Comédie Française, 99, avenue des Champs-Elysées,* 1910
Albumen silver print. Atget negative number 754 (Interiors)
Inscribed on verso: *Intérieur Sorel*
The Lynne and Harold Honickman Gift of the Julien Levy Collection,
2001-62-108

40. Albert Guillaume (French, 1873–1942), "Souverain Mépris,"
Le Rire, no. 594 (June 20, 1914). Bibliothèque Nationale, Paris.
Cartoon based on fig. 39

Atget's practice was open-ended. He did not direct his photographs toward a single destination or purpose, but rather designed them for various uses (very often, more than one use is discernible in a photograph), and then put them into the world to end where they may. In that sense Atget was the antithesis of a modernist artist; his photographs are anything but autonomous works of art. In Nesbit's words they are incomplete, waiting to be "finished" by their various buyers.[25] Atget began the Interiors series with photographs of his own rooms, and for whatever reasons he made them, he presumably decided that such views would sell well to his artist clients. He was correct—the cartoonists particularly liked them as settings for metropolitan comedy (figs. 39, 40). The photographs' usefulness as backgrounds is surely one reason for the open foregrounds in many of the compositions, as well as the mirror reflections that so fully describe the rooms' surroundings. One can imagine architects, furniture manufacturers, stage set designers, and decorators such as the eclectic Monsieur Cavaillé-Coll—whose home Atget visited three times to complete the series—finding other purposes for the details in each photograph. The clients would take whatever elements were useful for their own productions and leave the rest. An architect might look at the plaster moldings or the way an enfilade of rooms stretches through a series of doors. A stage set designer might copy a whole scene for a backdrop or simply take the arrangement of knickknacks on a mantle. And so

on. Once begun, the list of possible uses for these interior views is nearly inexhaustible. That is why Atget's business was steady. But Atget devised his own particular use for these photographs: the finished public albums he carefully composed for sale to his institutional clients. This must be why he crafted them into a contained series with so many echoes from photograph to photograph.

The real histories of the people who lived in these rooms did not matter very much for any use these photographs were put to. And yet, as noted, and as seen in what the cartoonists made of them, the photographs play around the edges of anecdote; they provoke personal questions. Perhaps that is because Atget photographed with the cartoonists in mind. But he also collected details when he photographed these rooms—clues to the habits, desires, compulsions, disappointments, and comforts of their owners: clutter tucked in corners; a wall of mementos; an antique chest perched on a platform like a museum piece, or a department store knockoff; a room stuffed with books, or devoid of them.

Léon Morat's apartment was one interior where Atget collected the evidence and split it in two. The first two photographs of his quarters depict a modest room that includes the apartment's cook stove and that the owner has papered and decorated into a dining area (fig. 41; see also fig. 116). These and a photograph of a sitting room offer three views of a neat but unremarkable home that Atget identified in the public album as *Intérieur d'un ouvrier, rue de Romainville* (Interior of a working-class man, rue de Romainville). By contrast, the two views of Morat's bedroom, which Atget ultimately named *Petite chambre d'une ouvrière, rue de Belleville* (Small bedroom of a working-class woman, rue de Belleville), offer the most personal view of a life to be found in the public album (figs. 42, 43). It is easy to see why Atget invested them with an invented character all their own; perhaps the room looked feminine to him, with its groupings of souvenir fans and packets of letters on the walls, and the neat array of plants, posies, photographs, and toiletries on the bureau and shelves. The diplomas with Monsieur Morat's name offer contrary clues. Whoever the occupant, this bedroom looks above all like the space of a person who lives alone: someone who has plastered his or her walls with the souvenirs of a dozen private occasions, and who revels in the small luxury of being able to do so.

Judging from the worksheet at the back of the Museum's album of interiors, it seems that when Atget was arranging the public album, he gave the most thought to his own home (worksheet nos. 690–91, 710–11, 734, 772–74) and that of Cavaillé-Coll (worksheet nos. 729–33, 745, 760–62). Atget considered naming a view of his own bedroom washstand (see fig. 48) and all the photographs of Léon Morat's rooms as "the author's," thereby identifying them as his own, but he rejected the idea in favor of splitting the group between the *ouvrier* (working-class man) and the *ouvrière* (working-class woman). Atget also thought to place the pair of kitchen views immediately after this group, presumably to identify them with the workers' homes rather than with that of the *négociant*, which is depicted in the following group. When organizing the views of Cavaillé-Coll's rooms, Atget kept six together and ultimately identified them as the interior of Monsieur C., decorator in the rue du Montparnasse (fig. 44). However, he gave the last three views to a new character, labeled on the worksheet as *collectionneur* (collector), who in the public album would receive the

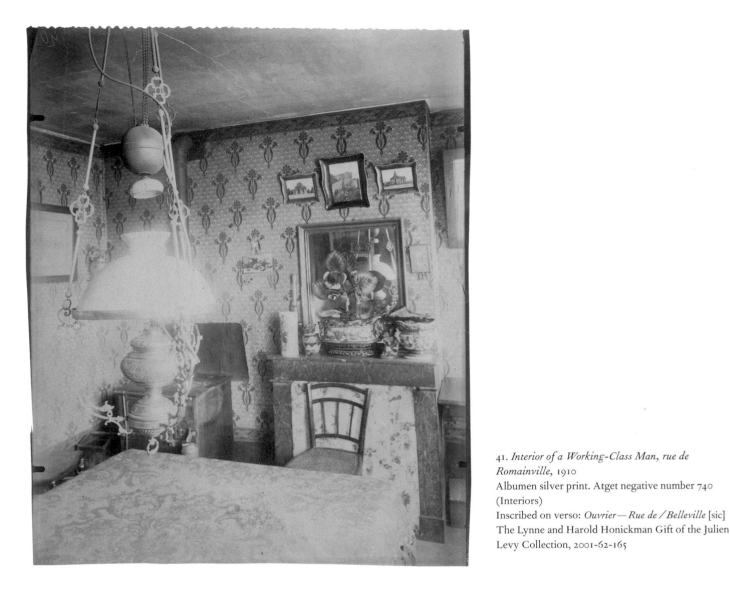

41. *Interior of a Working-Class Man, rue de Romainville,* 1910
Albumen silver print. Atget negative number 740 (Interiors)
Inscribed on verso: *Ouvrier — Rue de / Belleville* [sic]
The Lynne and Harold Honickman Gift of the Julien Levy Collection, 2001-62-165

moniker "Monsieur B." and an address in the rue de Vaugirard (fig. 45). On the worksheet Atget added two views of his own salon to this new collector's dwelling, but ultimately he would assign them to Monsieur R., the dramatic artist in the rue Vavin (figs. 46, 47). These two photographs, which record one corner in Atget's apartment, do make it look like the center of a full intellectual life. The shelves groan with bound volumes and a thick mixture of knickknacks, including a few precious-looking things. The walls are crammed with art reproductions and other pictures. But when one of these views (fig. 46) was placed on an album page facing the elegant possessions of Monsieur B., collector (fig. 45), there was not much chance a thoughtful viewer would believe that the photographs depict the same interior.

Atget's wall of pictures in this corner of his apartment is intimately self-referential. At least eight of the images evoke earlier phases of his life, when he was a sailor, a soldier, and a stage actor. Just above the wooden shelf hang two of his own photographs; the one on the left depicts the spire of Saint-Etienne-du-Mont seen from the rue de la Montagne Sainte-Geneviève, and the one on

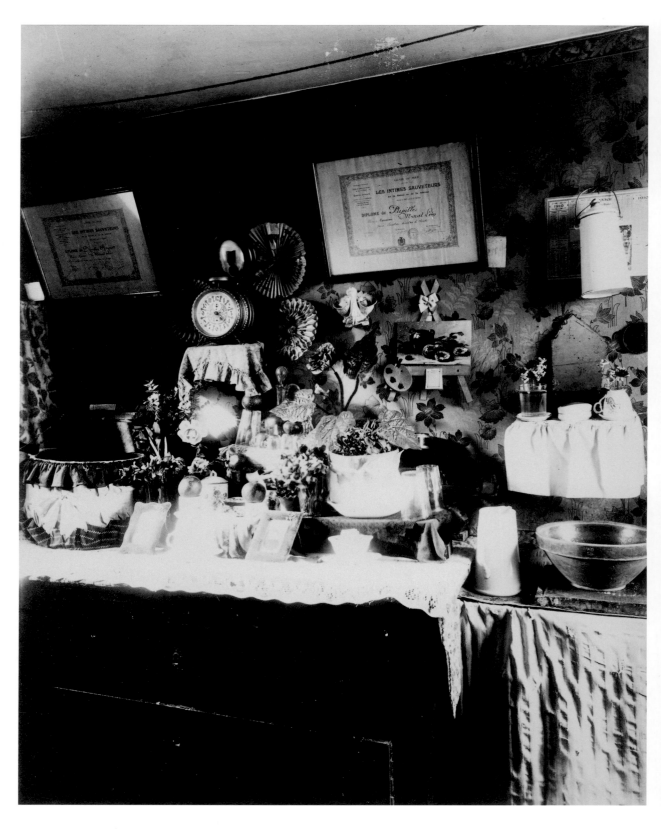

42. *Small Bedroom of a Working-Class Woman, rue de Belleville*, 1910
Albumen silver print. Atget negative number 744 (Interiors)
Inscribed (by Abbott) on mount verso: *Interieur Ouvrière*
The Lynne and Harold Honickman Gift of the Julien Levy Collection, 2001-62-112

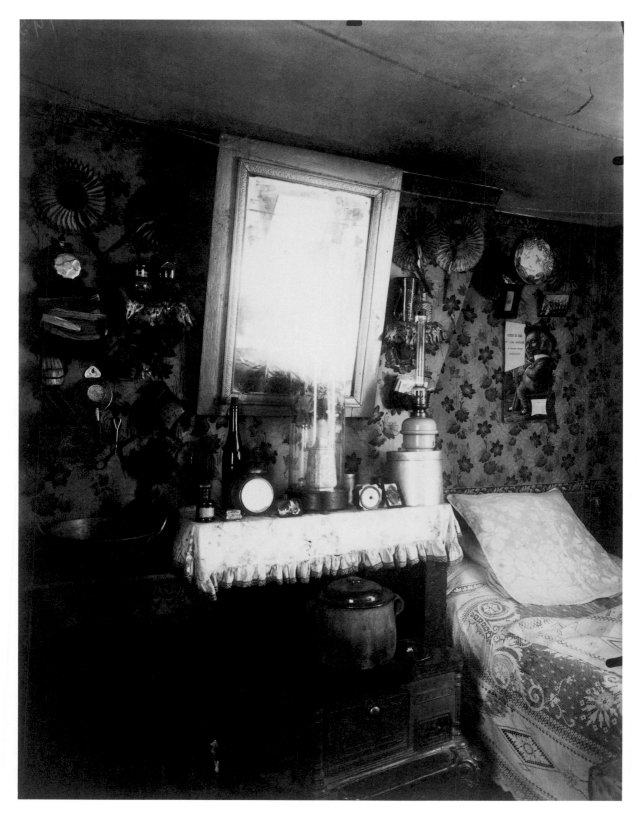

43. *Small Bedroom of a Working-Class Woman, rue de Belleville,* 1910
Matte albumen silver print. Atget negative number 743 (Interiors)
Inscribed (by Abbott) on mount verso: *Interieurs*
The Lynne and Harold Honickman Gift of the Julien Levy Collection, 2001-62-120

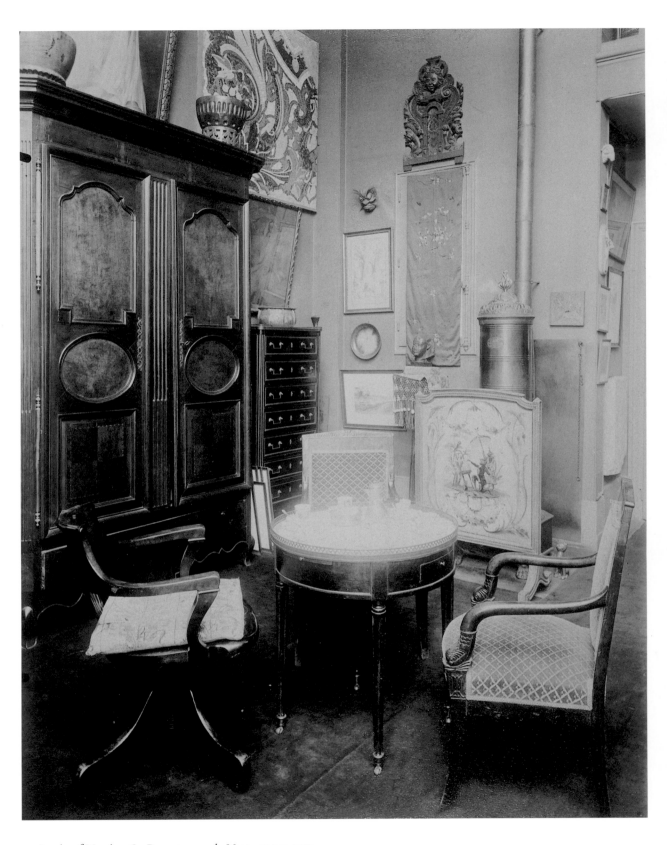

44. *Interior of Monsieur C., Decorator, rue du Montparnasse,* 1910
Albumen silver print. Atget negative number 745 (Interiors)
Inscribed (by Abbott) on mount verso: *M. C. Décerateur / R du Montparnasse*
The Lynne and Harold Honickman Gift of the Julien Levy Collection, 2001-62-161

the right shows trees along the small Bièvre River (see fig. 46).[26] It is tempting to surmise that both places represented something personal and important to Atget or Compagnon. But make no mistake: by design, such associations did not exist for library viewers of Atget's interiors album, nor for any customer who might buy this photograph. At most, the comfortable intimacy of the corner is evident. If Atget valued personal meanings in his living space, they had little place in his photographs.

Comparing Atget's workroom interiors album with its public version, it seems he used the workroom version to construct his subjects' identities, or, more precisely, to draw them out. In the public version of the album, the reader meets a cast of characters, whose truth or fiction is unimportant. Their constructedness is another matter. Consider a few things we know: Maurice de Féraudy, descended from ancien règime nobility, became an actor—to his family's displeasure—and found his most famous role as a businessman.[27] Berthe de Féraudy, the sculptor in the rue Montaigne, always exhibited her work under the name "Ferraudy," dropping the aristocratic particle and changing the name's spelling, presumably to protect either her private or her professional life.[28] Cécile Sorel, on the other hand, was an actress with aristocratic fantasies, who actually managed, for a time, to be the Comtesse de Ségur through her marriage to a nobleman.[29] What do these anecdotal bits, paired with the photographs, suggest? We can grow into the roles we choose for ourselves, but we also can and somehow often do expose some of the facts behind the stagecraft. And the facts are typically more complex. Atget evidently thought so. In the rooms of a worker he found enough fodder for two identities, a woman and a man. Monsieur Cavaillé-Coll is duplicated in the same way, to become "Monsieur C.," decorator, and "Monsieur B.," collector.[30] And Atget gives us two clear views of himself: laborer and intellectual. It is simple, after all, to recognize the worker's washstand adjacent to the dramatic artist's modest salon: this is what albums are for (figs. 48, 49). Atget did not try to tie the two identities together very neatly, but he did tie them together.

To read personal anecdote into these pictures is not to read politics out of them. In Nesbit's reading, the public album of interiors is about modernity and social class—how the classes fall out in 1910, how their common desires and their absolute differences can be traced in the rooms they occupy.[31] Each absent subject finds a full personal stage in these portraits of his or her rooms. The viewer becomes absorbed with the album as with a novel or play, empathizing with and objecting to each character in turn. Such collective scrutiny is a persuasive way to level the players; the cool forensics of the captions level them even more. Unlike other aspects of his personal life, Atget's politics enter his work, but they do so obliquely, so that sometimes they do not seem like politics at all. Again and again he shows subjects in their contexts, which is to say he shows their relations to other things. In the arrangement of this album he also constructs the relation of one photographed subject to another.[32]

Atget proceeded to make five more albums to deposit in libraries between 1910 and 1915. As with the interior photographs, the pictures in these other albums had a number of uses, but the albums themselves were Atget's particular project, designed for a library shelf. The mode of organization varies consider-

45. *Interior of Monsieur B., Collector, rue de Vaugirard,* 1910
Albumen silver print. Atget negative number 762 (Interiors)
The Lynne and Harold Honickman Gift of the Julien Levy Collection, 2001-62-302

46. *Interior of Monsieur R., Dramatic Artist, rue Vavin*, 1910
Albumen silver print. Atget negative number 772 (Interiors)
Purchased with the Lola Downin Peck Fund, the Alice Newton Osborn Fund,
other Museum funds, and with the partial gift of Eric W. Strom, 2004-110-9

47 . *Interior of Monsieur R., Dramatic Artist, rue Vavin,* 1910
Albumen silver print. Atget negative number 773 (Interiors)
The Lynne and Harold Honickman Gift of the Julien Levy Collection, 2001-62-304

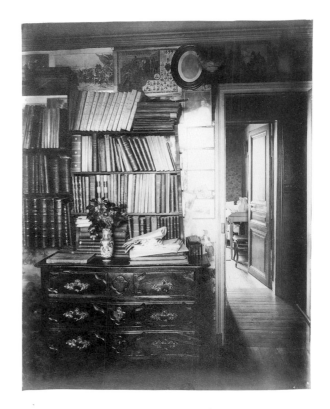

ably among the albums—strong evidence of how deeply Atget thought about this format.[33] Each one consists of sixty photographs and takes some aspect of modern life as its subject: vehicles (see figs. 68–70); trades and shop displays (see fig. 73); shop signs and storefronts (mostly cafés; see fig. 79); ragpickers and their quarters (see figs. 88–90); the landscape outside the walls of Paris, known as the *fortifications*, which was a place for lower-class leisure but also for wartime maneuvers when Atget made the album in 1915. Atget did not assemble similar public albums out of his thousands of photographs of other subjects.

Photographs of Versailles

We cannot identify an idea, a subject, or even a style common to Atget's park photographs. He never formed groups of them into finished albums like the ones of modern subjects described above. Perhaps he decided that the parks, already well known, did not require them. Perhaps he found the subject too broad for the kinds of album he liked to make. In any event, Atget's park photographs do not offer—in part or in sum—a consistent image of their subjects. Consider Versailles: Atget photographed the views, the sculptures, the gardens, and the palace of Versailles over many years, most intensively between 1901 and 1906, and again between 1921 and 1926. The Julien Levy Collection includes many of the 1904 Versailles photographs, because they were interleaved in the interiors album when Levy acquired it, and numerous more from the 1920s, evidently because Levy liked those and sought them out. Even if we were to look outside the particular clusters of Versailles photographs in the Julien Levy Collection, we would see that Atget did not exhaustively document the park, nor did he

LEFT:
48. *Interior of a Working-Class Man, rue de Romainville*, 1909–10
Printed by Berenice Abbott, c. 1930
Gelatin silver print. Atget negative number 711 (Interiors)
The Lynne and Harold Honickman Gift of the Julien Levy Collection, 2001-62-339

RIGHT:
49. *Interior of Monsieur R., Dramatic Artist, rue Vavin*, 1909–10
Albumen silver print. Atget negative number 691 (Interiors)
Bibliothèque Nationale, Paris

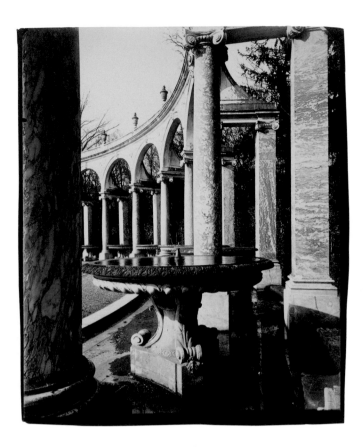

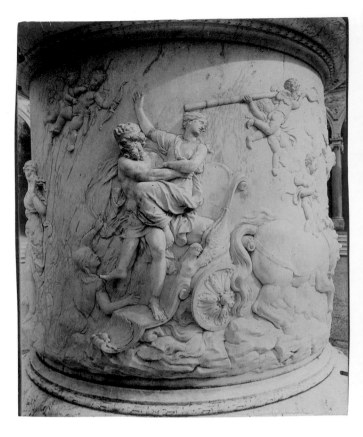

50. *Versailles—Bosquet de la Colonnade,* 1904
Albumen silver print. Atget negative number 6473 (Environs)
Inscribed on verso: *Versailles*
The Lynne and Harold Honickman Gift of the Julien Levy Collection,
2001-62-280

51. *Versailles—Bosquet de la Colonnade,* 1904
Albumen silver print. Atget negative number 6474 (Environs)
Inscribed on verso: *Versailles Bosquet de la / Colonade*
The Lynne and Harold Honickman Gift of the Julien Levy Collection,
2001-62-249

ever craft his Versailles pictures as a representation of the whole thing. As with
his other photographs, he made them with multiple customers in mind. Many of
the photographs demonstrate a variety of potential uses, but often one purpose
dominates a given image. As a result, even within a set of photographs of a
single motif, there is no unifying style.

In 1904 Atget made at least ten photographs of the Bosquet de la Colonnade
(Grove of the Colonnade), an element of the park at Versailles designed by
Jules Hardouin-Mansart in 1684, which featured at its center François Girardon's famous sculpture *The Rape of Proserpina* (c. 1675–94, dated 1699).[34] Three
photographs demonstrate the variety Atget sought within this set (figs. 50–52).
The photographs look nothing alike, but there is logic to the group. Atget recorded the architectural elements of the colonnade, made some views of the central sculpture in its setting, and moved in for close records of the relief carvings
on the statue's base. These three very different photographs pursue three different yet related subjects: architecture, topography, and sculpted detail. Taken
together, the set captures the Bosquet's materials, its setting, and the effects of
water and light. Taken individually, the view within the colonnade (fig. 50) offers the details of one fountain and one column capital, along with their relation to their fellows in file behind them. The view of the central statue (fig. 52)

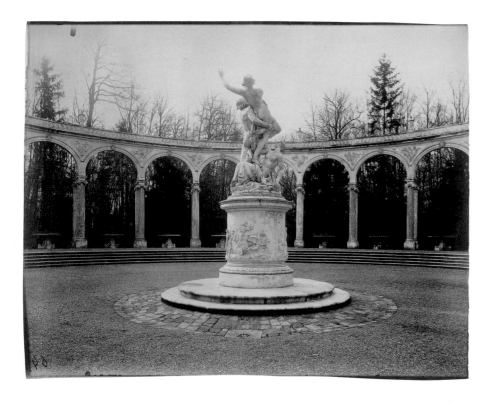

includes a large dose of the setting, which is crucial for comprehending the whole and would appeal to anyone concerned with the scenography of the place. The cropped view of the sculpture base (fig. 51) gives fully one-half of its relief, which Atget complemented with slivers of background on either side—these provide orientation, scale, and an exciting frame for the prancing figures on the relief. They also offer a bit of context, but that is far less important here than in the broad topographical view.

If Atget had a general purpose in his photography at Versailles, it was topography. His most reliable clients, the libraries, would buy many of his park and garden photographs, regardless of emphasis, for their topography files. Moreover, Atget approached the park topographically, ticking off sections and sculpture groups picture by picture, especially in his earlier campaigns from 1901 to 1906. But the unity of the photographs ends there. The Bosquet de la Colonnade photographs share only their subject; even their comprehensiveness is undone by their disparate purposes and looks. This is not simply because Atget made them with multiple customers in mind. These photographs are documents of a high order, made to draw out as many of the subjects' qualities as Atget observed and could show in a photograph. A pair of duplicate albumen silver prints of the opposite side of the sculpture's base from that seen in figure 51 display Atget's care with these records (figs. 53, 54). As seen in the difference between them, the effect of light and shadow, so important when viewing reliefs, can be altered significantly from print to print, all the while preserving the nuances of the middle tones captured in the negative.

Atget brought a range of formal tools to bear in Versailles. Some of them we have already seen: if he made a fragmentary or close-up photograph of a sculpture base or a vase, he typically worked a slice of background into one or both

sides (fig. 55). He photographed individual sculptures against trees for the effect of relief—the backdrop might be a curtain of summer foliage (fig. 56) or a staccato caning of bare winter trunks (fig. 57). When mapping topography, he often twinned a foreground vase or sculpture with others in the distance, producing an odd sense of doubling while simultaneously laying out the scale and character of a space (figs. 58, 59). Atget arrived at most of these devices quite early, and he put them to work consistently over many years of photographing in Versailles. It is not easy to date his Versailles photographs simply by looking at them. One often must know an image's negative number to be confident that it was made in 1904 or 1924, as the styles of the various campaigns are so much the same.

Atget exaggerated on occasion, deflating Versailles' overblown grandeur with visual repartee. Some of his photographs are positively cartoonish in the ways they compound the dimensions and symmetries of the place. One 1904 view depicts an allegorical sculpture of the Loire River, at the Bassin du Sud (Southern Basin), one of two reflecting pools adjacent to the palace (fig. 60).[35] Having accommodated the whole sculpture and one indicative corner of its plinth in the frame, Atget sliced the other end of the plinth and posed the deity like a giant about to stir. Photographed from a low viewpoint, *Le Loire*'s cornucopia vies with the tallest tree at left. His left foot looks poised to kick a minuscule urn on the other side of the pool, and his right foot menaces some fellow statues. Similarly, in 1921 Atget photographed the staircase of the Parterre du Nord (North Lawn), situated just above the Bassin du Nord (Northern Basin). Here, the staircase itself is the subject (he documented the statue and the vase at other times), and again Atget placed his camera low to the ground (fig. 61). The descending steps echo the palace a dozen times and take up much

COUNTERCLOCKWISE:

55. *Versailles — Vase by Cornu*, 1904
Albumen silver print. Atget negative number 6467 (Environs)
Inscribed on verso: *Vase par Cornu / Versailles*
The Lynne and Harold Honickman Gift of the Julien Levy Collection,
2001-62-233

56. *Versailles — Park*, 1922
Albumen silver print. Atget negative number 1154 (Versailles)
Inscribed on verso: *Versailles (Parc)*
The Lynne and Harold Honickman Gift of the Julien Levy Collection,
2001-62-238

57. *Versailles — Faun*, 1901
Albumen silver print. Atget negative number 6199 (Environs)
Inscribed on verso: *Versailles (Faune)*
The Lynne and Harold Honickman Gift of the Julien Levy Collection,
2001-62-236

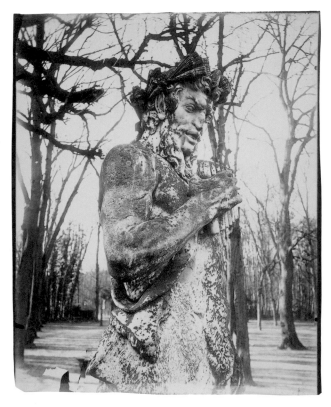

58. *Versailles—Bosquet de l'Arc de Triomphe*, 1904
Gelatin silver chloride print. Atget negative number 6486 (Environs)
Inscribed on verso: *Versailles—Bosquet de L'arc / de Triomphe*
The Lynne and Harold Honickman Gift of the Julien Levy Collection, 2001-62-257

59. *Versailles*, 1922–23
Albumen silver print. Atget negative number 1195 (Versailles)
Inscribed on verso: *Versailles*
The Lynne and Harold Honickman Gift of the Julien Levy Collection, 2001-62-274

60. *Versailles—Bassin du Sud*, 1904
Matte albumen silver print. Atget negative number 6518 (Environs)
Inscribed on verso: *Versailles (Bassin / du Nord* [sic]*)*
The Lynne and Harold Honickman Gift of the Julien Levy Collection, 2001-62-239

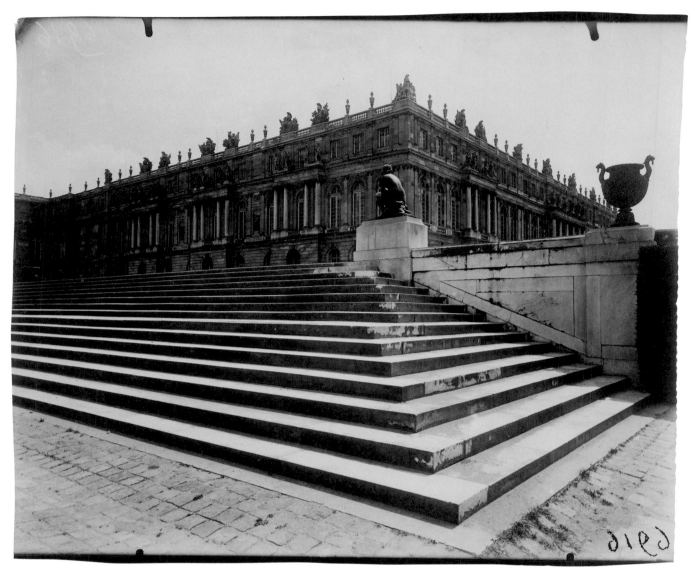

61. *Versailles,* 1921
Albumen silver print. Atget negative number 6916 (Environs)
Inscribed on verso: *Versailles*
The Lynne and Harold Honickman Gift of the Julien Levy Collection, 2001-62-282

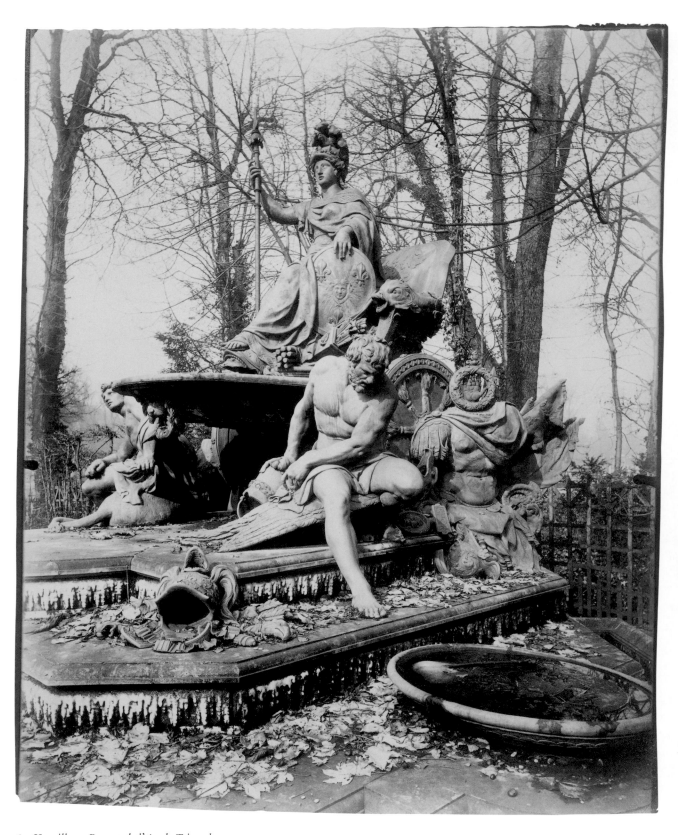

62. *Versailles — Bosquet de l'Arc de Triomphe,* 1904
Albumen silver print. Atget negative number 6479 (Environs)
Inscribed on verso: *Versailles — Bosquet de / L'arc de Triomphe*
The Lynne and Harold Honickman Gift of the Julien Levy Collection, 2001-62-252

more room, while the angled wedges of cobblestone mirror the shape of the sky at top—all of it like a doubling run amok, as if in catty riposte to the reflecting pools nearby.

Atget liked a good visual joke. He also liked to enlist the figures in his photographs, whether statues, tabletop figurines, or two-dimensional images. He marshaled them all like so many accomplices, to laugh, frown, entice, or point to something else in the frame. So it is no surprise that he was especially skilled at the art of photographing sculptures. In Versailles, in winter or late autumn 1904, he photographed all the works around the Bosquet de l'Arc de Triomphe (Grove of the Triumphal Arch), another section of the park he tackled that year, like the Bosquet de la Colonnade, but with somewhat more stylistic consistency. In one record of the central sculpture, *La Fontaine de la France triomphante*, he arranged the view so that a forlorn-looking subsidiary figure in the foreground gazes down at strewn leaves and an ice-clogged pool, as if despondent about the disorder (fig. 62).[36] More than twenty years later, in 1926, he photographed a group of sculpture busts on pedestals in a wooded area of the Trianon (fig. 63). The sculptures meander into the forest almost randomly, as if they had been in place long before the trees. Their relationship to one another in the photograph is established by the first bust, which gazes in the direction of the second. The second bust, however, seems to respond with a game of hide and seek, protected by the large tree at center-left and a serendipitous spray of ivy.

Numerous threads run through Atget's photographs of Versailles, but altogether the work produces a babble about the park, not a narrative. There are instances where Atget seems to revel in taking a contrary stance before his magisterial subject—the low vantage points and outsized motifs in figures 60 and 61 are great examples. Other times he treats the whimsy or elegance of a given motif with reverence. The photographs are not conceived as a cohesive group, nor are they autonomous works of art: like all of Atget's work they have great effect in groups (in library picture files or even in one of his simple workroom albums). And always, they are designed to serve as many uses as Atget had clients. Atget's American admirers would resist these multifarious and rather incomplete qualities of his work. Abbott and Levy each fit Atget's photography into categories of art and purpose they could better understand. That is no crime—the two of them were sharp-witted viewers of his photographs, and their observations are worth savoring. But they missed some things. Consider again Atget's scene of the Parterre du Nord (see fig. 61). Levy probably viewed this with other staircase photographs by Atget in mind (see fig. 87). The Surrealists prized his staircases for the suggestive obscurity they drape onto the everyday. The Parterre du Nord photograph goes even further: it distorts rational space, a primary Surrealist endeavor. Atget evidently valued that distortion too, but not for its own sake. What did he see in the photograph? Perhaps a stage set, a library file, an architect's portfolio—and for all of them, a witty rebuke to pretense.

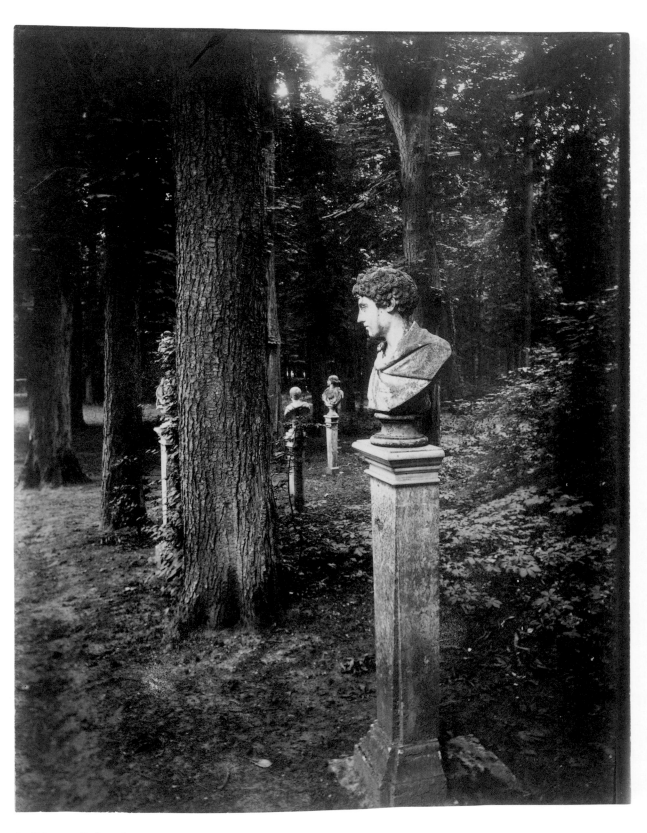

63. *Trianon—Park*, 1926
Matte albumen silver print. Atget negative number 1257 (Versailles)
Inscribed on verso: *Trianon (Parc)*
Purchased with the Lola Downin Peck Fund, the Alice Newton Osborn Fund,
other Museum funds, and with the partial gift of Eric W. Strom, 2004-110-28

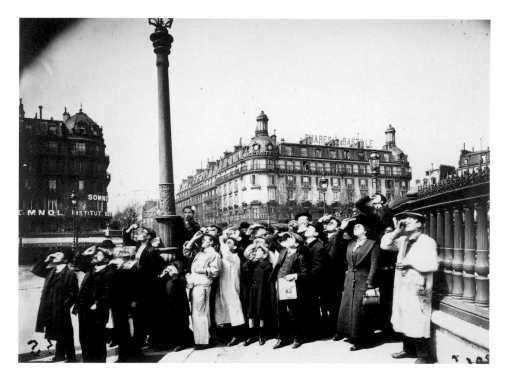

64. *During the Eclipse, place de la Bastille, April 17,
1912,* 1912. Printed by Berenice Abbott, c. 1930
Gelatin silver print. Atget negative number 335
(Picturesque Paris, Part II); formerly Atget negative
number 891 (Landscape-Documents)
Inscribed (by Abbott) on mount verso: *Pendant
L'Eclipse 1910* [sic]
Gift of Carl Zigrosser, 1953-64-33

Abbott and Levy Looking at Atget

In Berenice Abbott's telling, when she asked Atget if the French appreciated
his work, he replied, "No, only young foreigners."[37] His laconic bemusement
at the situation does not suggest that he made distinctions among the admir-
ing youngsters, but he seems to have shown more tolerance for Abbott than
for Man Ray. Consider Atget's portrait session in Abbott's studio, to which
Abbott invited him after many visits to his workroom and discussions about
his photography, and for which Atget arrived in a nicer coat than she expected
(see frontispiece).[38] His evident gratitude to her is far from his famous dismissal
to Man Ray, when the latter sought permission to publish—on the cover of *La
Révolution surréaliste*—Atget's photograph of a crowd watching an eclipse (fig.
64). Atget let him use the picture, but Man Ray recalled him saying: "Don't put
my name on it. These are simply documents I make."[39]

Berenice Abbott and Julien Levy both learned about Atget from Man Ray,
who lived on Atget's street, the rue Campagne-Première, from 1921 until the
1930s. Man Ray found the man and the pictures curious, so he told his friends
about Atget and bought around fifty photographs himself. His interest was brief,
however, and it did not demonstrably color his own photography, which took
place largely within his studio.[40] It seems Man Ray viewed Atget entirely from
the context of Surrealism. The Surrealist movement, several years old in 1926
when Man Ray published Atget's pictures, involved a great deal of photography,
including Man Ray's. But Surrealist photographic practice was not codified; the
Surrealist photograph was never defined. This was partly because Surrealist
practice revolved around chance, partly because the status of visual art in the
movement was never stable, and partly because there are so many things about
photographs that brush against Surrealist principles. There is much to say, for

example, about the formal strategies Atget's photographs share with Surrealist ones. Nevertheless, for Man Ray, Atget's pictures—curious formal qualities aside—were primarily *objets trouvés* (found objects), as was Atget himself.

Surrealism cut across mediums and disciplines; it was hard to define. Julien Levy would call it a point of view when he compiled a book on the topic in 1936. Conceived against reason but not having a dominant style or a single set of materials, Surrealism was woven of strategies, two of the most crucial being automatism and found objects. The idea of automatism was simple: if the mind could be freed to write or draw (or do anything else) without direction, the results would somehow skirt representation, offering a direct trace of the producer's unconscious, above all, his or her unconscious desires. Surrealism's chief weapon against reason, after all, was sex, the madness that undoes so much of our rational behavior.[41] A found object held similar appeal: a thing picked up anywhere, divorced from its context or use, might shock the beholder with its powerful blend of the commonplace and the unfamiliar, recalling one's innermost desires to oneself, granting access to one's own unconscious. All the better if the object were old or outmoded; the eruption it triggered of past into present would displace the beholder not only from conscious reality but from rational time as well.

Old photographs were things from another moment, full of people and places nobody knew. They came very close to *not* being representation, being cuts from reality as opposed to composed pictures (according to some people).[42] In this sense their automatism was social, not personal—like a dream, they uncovered the desires of an epoch. The cultural critic Walter Benjamin saw political potential in this, as did many of the Surrealists. Benjamin called outmoded things "the wish-symbols of the last century," and he claimed them for a critique of capitalism's incessant destructions in the name of progress; in this spirit he would famously compare Atget's photographs—absent of players but full of evidence—to the scene of a crime.[43] Not Man Ray: "I don't want to make any mystery out of Atget at all. He was a simple man and he used the material that was available to him when he started in 1900—an old rickety camera with a brass lens on it and a cap."[44] Printed out from large glass negatives, most often on albumen paper, which nobody used anymore, Atget's photographs reeked of the nineteenth century even if they had been made in 1925. And Atget himself, who slowly made his way through Paris with his view camera, his tripod, and his glass negatives, was another leftover from fifty years before. Levy remembered that Man Ray had tried unsuccessfully to lend Atget his modern Rolleiflex camera; Man Ray offered to make "modern" prints for Atget as well, to no avail.[45] The old man refused; perhaps he wondered if the offers were made just to watch his response.

In 1926 Man Ray arranged his Atgets in an album of his own design (fig. 65). Having visited Atget's workroom, Man Ray knew about the stacks of paper storage albums such as those now in the Philadelphia Museum of Art. (None of the young *avant-gardistes* understood the scope of Atget's business, so they did not know about the finished, public albums and the many other photographs he had sold to Paris libraries.) Man Ray recalled, "He printed on a little frame, putting it outside his window to dry in the backyard in the sun, and as soon as he had

65. Man Ray (American, 1890–1976)
Photo Album—E. Atget, 1926
8¼ x 11⅝ inches (21 x 29.5 cm)
George Eastman House, Rochester, New York

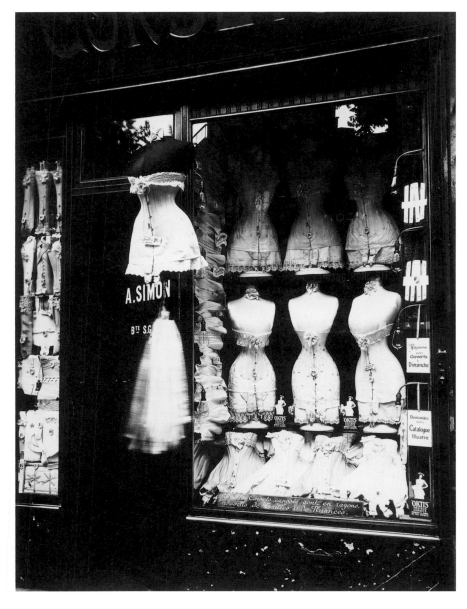

66. *Boulevard de Strasbourg, Corsets*, 1912
Gelatin silver chloride print. Atget negative number
379 (Picturesque Paris, Part II)
Inscribed (in an unknown hand) on mount verso:
Boulevard de Strasbourg / Corsets
Gift of Carl Zigrosser, 1953-64-40

the prints, he put them in a book."[46] Man Ray's own book of Atget's prints looks like a family photograph album.[47] Maybe he intended a comic sleight-of-hand in the act of removing the pictures from one modest setting and inserting them in another, parallel one. No doubt he thought this sort of parlor album—meant for family pictures—offered a wonderful context for the photographs themselves, which he found strange. Man Ray's taste in Atgets was particular. He liked some pictures of old Paris, especially staircases and doorways; scenes of circuses and fairs; ragpickers; prostitutes; and shop fronts, especially those with window reflections and mannequins (fig. 66). He said later that his were the ones with "a Dada or Surrealist quality about them."[48]

Abbott had known Man Ray for a number of years when he introduced her to Atget's photography. In 1918, at the age of twenty, Abbott made her way from Columbus, Ohio, to New York City. She studied sculpture and became friendly with writers and artists, among them Man Ray and Marcel Duchamp. In 1921 she decamped to Europe and pursued further sculpture training in Paris

and Berlin. In 1924 Man Ray, by then the proprietor of a fashionable portrait studio in Paris, hired her as his studio assistant, precisely because, Abbott later recalled, she did not know photography.[49] Within two years, however, Abbott had become a superb portraitist (see frontispiece, fig. 2). In 1926 she had a one-woman gallery show. Around the same time she opened her own portrait studio with financial backing from Peggy Guggenheim. (Guggenheim also underwrote the lampshade atelier of the Dada poet Mina Loy, a friend of Abbott's who would become Julien Levy's mother-in-law in 1927.) Abbott's clientele, like Man Ray's, was a healthy mix of avant-garde personalities and wealthy patrons. Unlike Man Ray, Abbott did not make other photographs; she joined no avant-garde. (She would experiment with the medium upon her return to the United States.) Her portraits are spare, subtly lit, and cannily composed. The photographs from Atget's sitting, for example, reveal his weariness at the same time they monumentalize him. In his great black coat, photographed from below and quite far back, he is a dignified, somewhat unknowable figure, close to how Abbott and others portray him in their writings; it seems to be the public face Atget chose for himself. In the portrait he fills the frame in a great stooped L, almost as substantial as a subject by Nadar, the nineteenth-century portraitist Abbott revered. But Atget's parted legs belie his suggested bulk; his hair is unkempt, his lips slightly separated, his neck scruffy.

Abbott first saw Atget's photographs in Man Ray's studio in 1925 or 1926. Here are her words about the encounter as recalled in 1964: "Their impact was immediate and tremendous. There was a sudden flash of recognition—the shock of realism unadorned. The subjects were not sensational, but nevertheless shocking in their very familiarity. The real world, seen with wonderment and surprise, was mirrored in each print. Whatever means Atget used to project the image did not intrude between subject and observer."[50] The photography historian Abigail Solomon-Godeau has observed that Abbott's choice of words in this passage reveals her knowledge of Surrealist theory.[51] The shock of familiarity was indeed essential to the Surrealist engagement with photography in the 1920s and 1930s. And Abbott did know her Surrealism. She hews remarkably close to it here, even in her final claim that Atget's means—his camera and negatives and prints—served to offer up his subjects as he found them, almost without mediation. But Abbott is describing something quite opposite to Surrealism. Consider some more of her words: "Atget's photographs, the few I knew, somehow spelled photography to me."[52] Abbott found clarity—an alphabet—in these pictures, not the distortions of Surrealist play (fig. 67).

Abbott began to visit Atget in his workroom. She bought small numbers of prints and asked him about his work. He showed her how he developed his negatives; he explained that he usually employed a small aperture and long exposures. According to Abbott and others, Atget was formal with visitors, but haltingly, increasingly talkative. He told Man Ray he painted landscapes. He told Levy he had been a sailor. He told Abbott that nobody knew what to photograph.[53]

Julien Levy's path to Atget's workroom was somewhat different than Abbott's. Julien was a precocious child of privilege. One day in 1927, at the Brummer Gallery in New York, he persuaded his father to buy a Brancusi sculpture, in addition to some antique chairs. Marcel Duchamp was at the gallery that day:

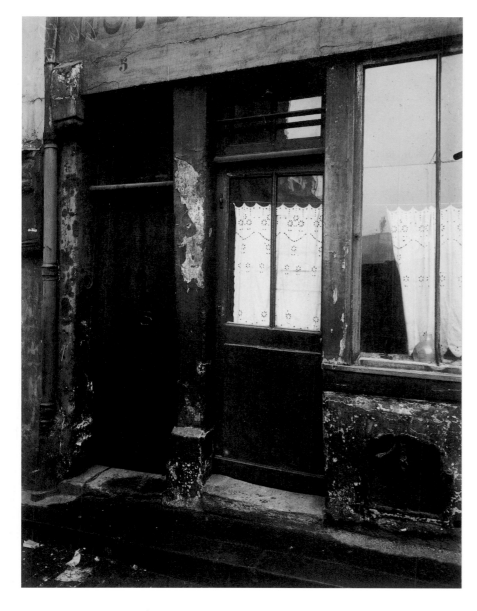

67. *Impasse Chartière*, 1924
Matte albumen silver print. Atget negative number
6480 (Art in Old Paris)
Inscribed (by Abbott) on mount verso: *Impasse
Chartiere / 1924*
The Lynne and Harold Honickman Gift of the Julien
Levy Collection, 2001-62-88

he owned partial interest in the Brancusi. Not surprisingly, Duchamp took a
liking to young Julien, who was just twenty-one and had recently dropped out
of Harvard. Levy had studied art, and he wanted to make films. Duchamp in-
vited Levy to return with him to Paris, and six weeks later they sailed together,
planning to make a film with Man Ray's camera equipment.[54] The film never
happened, but Levy got to know Man Ray, and he saw the Atget photographs
published in *La Révolution surréaliste*. They evidently sparked his excitement.
In the months before Atget's death, Levy became his most devoted collector
among "the young foreigners," visiting Atget's workroom often and buying as
many prints as the photographer would sell, and occasionally finding others at
commercial picture archives.[55]

In August 1927 Abbott learned of Atget's death when she tried to deliver
his portraits to him. Concerned about the disposal of his many photographs,
she tracked down his friend and executor, André Calmettes, and sought to buy
the entire collection. In the spring of 1928 Calmettes agreed to sell her what

remained, and Abbott acquired around 1,300 negatives and 7,000 prints. (In 1920 Atget had sold 2,600 of his Art in Old Paris negatives, all having to do with art and architecture in the city, to the Service Photographique des Monuments Historiques. Calmettes sold or gave an additional two thousand negatives of the same type of subject matter to the Service after Atget's death.)[56] In 1929 Abbott brought the collection back to the United States. At some point, knowing that Levy shared her passion for the work, she approached him for financial ballast, and by May of 1930 he became her silent partner. Levy ultimately contributed two thousand dollars, and he also insured the collection for that amount in 1932.[57] According to Levy's recollections, they agreed to keep the collection together and to sell Abbott's prints from Atget's negatives, as well as small numbers of duplicate prints by Atget himself.[58]

In 1930 Levy had started laying plans for his own New York gallery of modern art, conceived as a space devoted to photography, which would open in 1931. For the time being he worked at the Weyhe Gallery in New York, an art gallery and shop for fine and rare books. Levy was hired as an assistant to Carl Zigrosser, director of the art gallery, which regularly featured modernist prints, drawings, paintings, and sculptures. (Zigrosser would become the first curator of the Philadelphia Museum of Art's print department in 1940.) As for Abbott, she had written an article about Atget in 1929, for the magazine *Creative Art*, and she was actively lending his photographs for exhibitions and publications. She had found a French publisher to produce an Atget book, comprised of pictures she selected herself with an essay by Pierre Mac Orlan, a chronicler of Parisian popular life who had met Atget and who had written several articles about photography in the 1920s.[59] By March of 1930 Levy convinced Erhard Weyhe to pay for an American edition of Abbott's book, *Atget Photographe de Paris*, and to permit him to organize an Atget show at the Weyhe Gallery to coincide with the book's release.[60] This seems to be the moment when Abbott began printing from Atget's negatives.

The Philadelphia Museum of Art's collection of Atget photographs includes eighty-three prints made from Atget's negatives by Abbott around 1930.[61] Most are trimmed and mounted on card stock for exhibition and bear Abbott's stamp on the versos. There are also seventy-one of Atget's own prints on the same card stock, again with Abbott's stamp. These exhibition prints were probably prepared for the 1930 Weyhe Gallery show or for subsequent exhibitions at the Julien Levy Gallery. The subject matter and the appearance of the photographs provide a glimpse of the Atget that Abbott and Levy put forward in the United States around 1930.

Like Abbott's 1930 book, these photographs offer a fairly broad view of Atget's subjects. Abbott and Levy were both catholic in their enthusiasm for Atget. To their credit they embraced all of his work as they knew it. Abbott went so far as to include examples of his most basic art reproductions—paintings *in situ*, plaster casts mounted on a copy stand—in some of her publications on him. But Levy and Abbott had their preferences. The photographs Abbott prepared for exhibition around 1930 emphasize Atget's early pictures of street trades, his interior photographs, his views of shop displays, his photographs of ragpickers, and his 1920s photographs of prostitutes. They also include vehicle pictures

(figs. 68–70) and tree studies (figs. 71, 72), both of which Abbott particularly valued, presumably for their objective treatment of the subjects and the evident love Atget brought to them. By comparison, Atget's photographs of the great French parks and his early landscape studies, which are today among his most familiar works, received little attention. And his documentation of the art and architecture of Paris, much of which Abbott and Levy did not know, received little space relative to its centrality in Atget's career.

In all her discussions of Atget, Abbott spoke plainly about how his prints looked. In 1964 she wrote: "As there was never any preciousness in his entire approach, neither was there any in his finishing methods. It is quite possible that there was no time for it. Prints were not trimmed; I doubt if he owned a trimmer. But on a few occasions he used scissors to remove the edges. He had composed his photographs to the very edges of the plates so that the clamps which held the plates in the plate holders intrude upon the picture."[62] When Abbott mounted Atget's prints for their gallery presentation, however, she aestheticized them. She trimmed the prints into perfect rectangles; sometimes, not

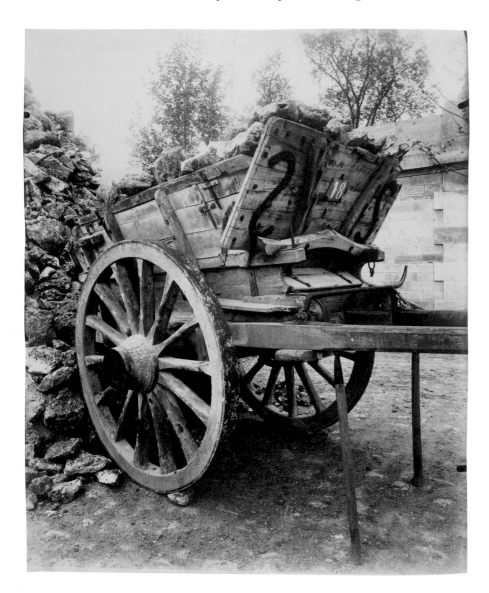

68. *Tip-Cart*, 1910
Albumen silver print. Atget negative number 11 (Picturesque Paris, Part II / Vehicles) Purchased with the Lola Downin Peck Fund, the Alice Newton Osborn Fund, other Museum funds, and with the partial gift of Eric W. Strom, 2004-110-3

69. *Market Cart, Saint-Germain Market*, 1910
Albumen silver print. Atget negative number 1 (Picturesque Paris, Part II / Vehicles)
Inscribed (by Abbott) on mount verso: *Voiture maraicher*
Purchased with the Lola Downin Peck Fund, the Alice Newton Osborn Fund,
other Museum funds, and with the partial gift of Eric W. Strom, 2004-110-33

70. *Carriage, Bois de Boulogne*, 1910
Albumen silver print. Atget negative number 55 (Picturesque Paris, Part II / Vehicles)
Inscribed (by Abbott) on mount verso: *Voiture—Bois de Boulogne*
Purchased with the Lola Downin Peck Fund, the Alice Newton Osborn Fund,
other Museum funds, and with the partial gift of Eric W. Strom, 2004-110-32

71. *Apple Tree — Detail*, 1919–21
Albumen silver print. Atget negative
number 954 (Landscape-Documents /
Mixed Documents)
Inscribed (by Abbott) on mount verso:
Pommier — détail
Purchased with the Lola Downin Peck
Fund, the Alice Newton Osborn Fund,
other Museum funds, and with the partial
gift of Eric W. Strom, 2004-110-20

72. *Saint-Cloud — Bouleau*, 1919–21
Matte albumen silver print. Atget negative number
925 (Landscape-Documents / Mixed Documents)
Inscribed (by Abbott) on mount verso: *St Cloud
(Bouleau)*
Purchased with the Lola Downin Peck Fund, the
Alice Newton Osborn Fund, other Museum funds,
and with the partial gift of Eric W. Strom,
2004-110-24

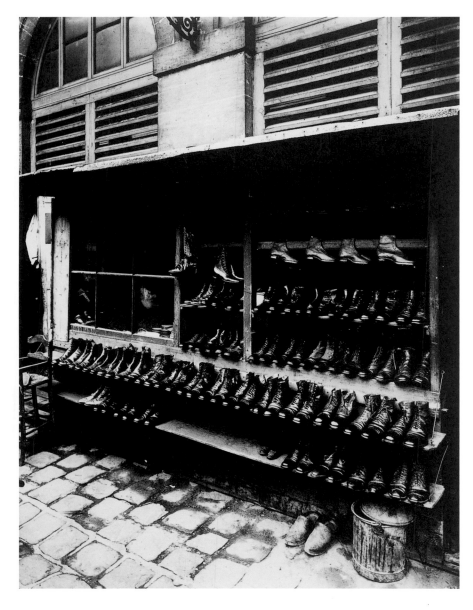

73. *Carmelites' Market, place Maubert,* 1910–11
Printed by Berenice Abbott, c. 1930
Gelatin silver print. Atget negative number 236
(Picturesque Paris, Part II)
Inscribed (by Abbott) on mount verso: *Marché des Carmes, place Maubert*
Gift of Carl Zigrosser, 1953-64-41

always, she cropped the negative clips and negative numbers, and sometimes she concealed them by other means. Abbott's small acts of neatening pushed Atget's photographs toward being full-fledged pictures, polished for their new role as photographic art. Her own prints from Atget's negatives are similarly perfect (fig. 73). It seems that she and Levy worked on these together. They are the prints that were intended for sale, and Levy was her first audience for various experiments to approximate Atget's own prints as closely as possible. Neither of them was fully satisfied with the effects Abbott achieved. Levy recalled: "We experimented with every paper we could find. You couldn't reproduce the depths of those red-brown dark tones of his prints. You came nowhere near it—you lost the whole feeling, even with the best papers: hand-coated, platinum, double hand-coated. We ended up, finally, with a semi-gold paper made by Gevaert. Then they dropped that in a year or two."[63]

The Museum's group of Abbott prints does indeed include a range of papers and tonal effects (see Price and Sutherland, pp. 103–20 below). And the prints

74. *Fair*, 1926
Printed by Berenice Abbott, c. 1930
Gelatin silver print. Atget negative number
95 (Picturesque Paris, Part III)
Inscribed (by Abbott) on mount verso: *Foire*
The Lynne and Harold Honickman Gift of
the Julien Levy Collection, 2001-62-332

do often run to harsh lights and darks, obscuring detail in shaded areas. This
was the source of Abbott's dissatisfaction. She found her own prints too con-
trasty, with few middle tones to balance the black and white extremes.[64] But in
numerous prints from the 1930s Abbott approximated the warm tones typical
of Atget's prints (fig. 74). More importantly, she simply made numbers of high-
quality prints, giving Atget's work a broader life. Abbott was a printer of great
skill, and she evidently believed her imperative was to preserve the information
and the relationships in Atget's negatives to her best ability. From two nega-
tives of storefronts with complicated window reflections, she produced shim-
mering positives, with every layer of information and image in play (figs. 75,
76). Sometimes, Abbott put the problem of contrasts to work for her. Levy
remarked in the 1970s that Atget's well-known photograph *Throne Street Fair*
(fig. 77) includes two spots of background visible in the negative, which Atget
always printed out of his positives, to achieve, in Levy's words, "this monu-
mental effect, in nothingness."[65] That may be so; it is certainly what Abbott
did with her prints from the negative, where the light bulb and the one-franc
entrance signs float against a sea of inky black.

In another of Abbott's prints, a view of the rue des Chantres, she achieved a
superb arrangement of sumptuous blacks and pencil-thin white highlights (fig.
78). These foreground a view beyond to the steeple of Notre-Dame, bathed
in light and aerial perspective. This is a remarkable photographic print, yet as
Abbott well understood, it bears little resemblance to what Atget would have
made from his negative. Small elements such as faded signage on the building
facade are lost. Others, such as the handle and window accoutrements at the left
edge (along with the negative clips), sink into the darks, softening the structural

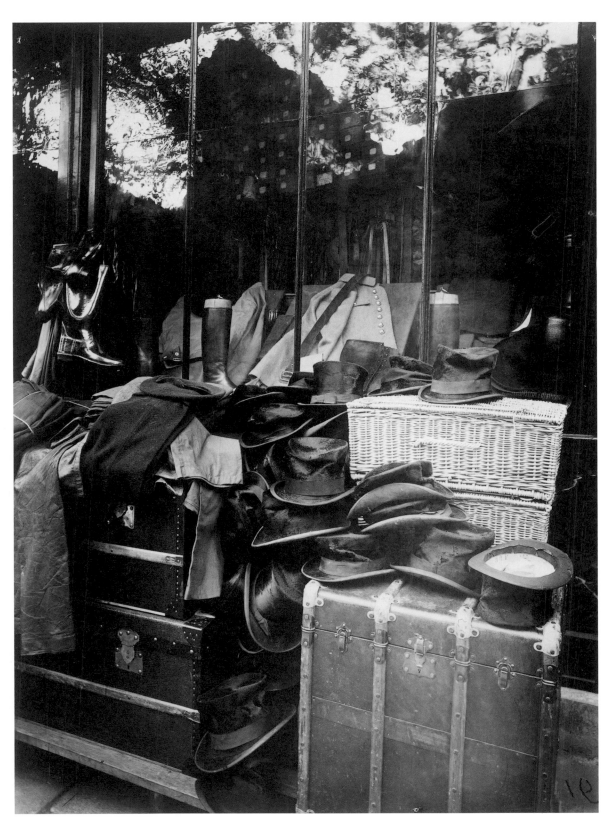

75. *Temple Market*, 1925. Printed by Berenice Abbott, c. 1930
Gelatin silver print. Atget negative number 91 (Picturesque Paris, Part III)
Inscribed (by Abbott) on mount verso: *Marché du Temple*
Gift of Carl Zigrosser, 1953-64-42

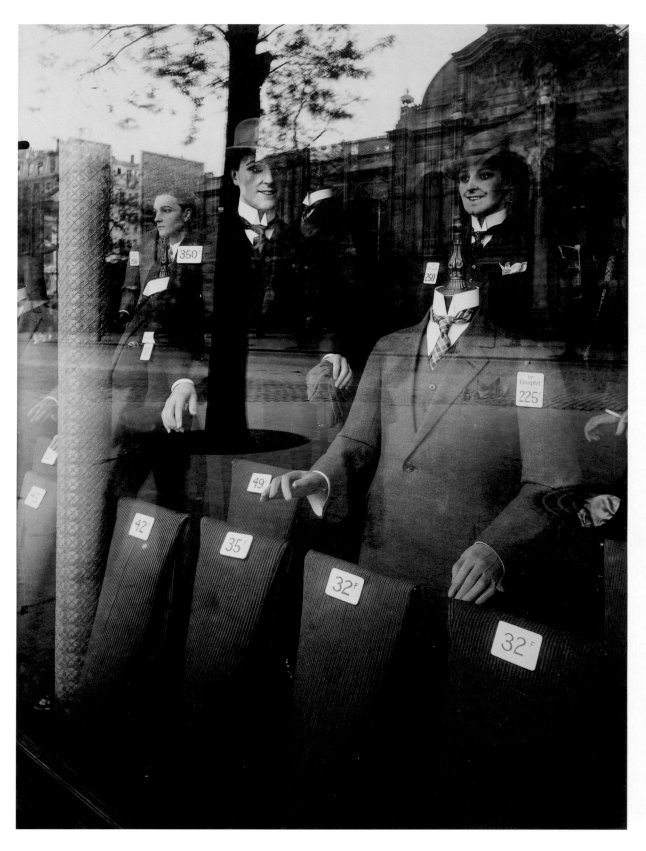

76. *Shop, avenue des Gobelins,* 1925. Printed by Berenice Abbott, c. 1930
Gelatin silver print. Atget negative number 83 (Picturesque Paris, Part III)
Gift of Mr. and Mrs. Carl Zigrosser, 1968-162-37

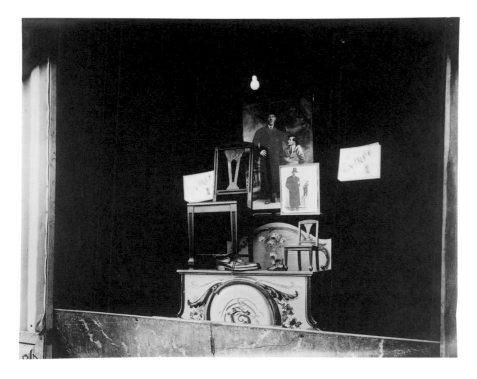

77. *Throne Street Fair*, 1925
Printed by Berenice Abbott, c. 1930
Gelatin silver print. Atget negative number 68
(Picturesque Paris, Part III)
Inscribed (by Abbott) on mount verso: *Foire*
The Lynne and Harold Honickman Gift of the
Julien Levy Collection, 2001-62-395

impact they have in albumen prints. But the real cost of such a beautiful print is not the loss of some detail, or even its flat, machine-age look, but the fact that it arranges itself into such a striking set of formal relations that those seem more important than the topographic work for which Atget designed the picture.[66]

When Atget composed his finished bound albums for deposit in the Bibliothèque Nationale, he too trimmed and neatly mounted his prints (although his edges still meander). Abbott and Levy knew only his workroom albums, and though they marveled at their contents, they did not consider the album format important to looking at Atget's work. They wanted to treat each print as an independent thing, like the autonomous creations of modernist art. But photography was not yet a full-fledged modernist medium. Aside from Alfred Stieglitz's succession of galleries and a few other occasional venues, artistic photographs usually found their market in the bookish settings of print shops like the Weyhe Gallery. Several of the mounted Atget prints in the Philadelphia Museum of Art, such as *At the Golden Shell* (fig. 79), retain a protective glassine cover sheet and a cover board with ATGET printed in elegant modern type on the front (fig. 80). It seems that the Weyhe Gallery (and later the Julien Levy Gallery) displayed many of the photographs in this format, in a print rack as opposed to on the wall. These presentation mounts offer an elegant solution, halfway between the book and the wall, that preserves the intimacy of viewing photographs, keeping it an individual experience—like a book or an album—as opposed to a public, museum-like one. Purchasers of multiple prints were evidently given portfolio cases in which to store the photographs. Carl Zigrosser, Levy's colleague at the Weyhe Gallery, owned twenty-one of the prints mounted by Abbott—seven printed by Atget and fourteen by Abbott—plus Abbott's portrait of Atget. Some or all of these were kept together in such a portfolio, which entered the Museum's collection with the prints.

78. *Rue des Chantres*, 1923. Printed by Berenice Abbott, c. 1930
Gelatin silver print. Atget negative number 6426 (Art in Old Paris)
The Lynne and Harold Honickman Gift of the Julien Levy Collection, 2001-62-342

There is a paradox in the collaboration of Abbott and Levy, two headstrong people, to promote Atget's work in the 1930s. Abbott, when she secured the contents of Atget's workroom and made herself guardian of his work, simultaneously relinquished her place in avant-garde circles. This was her choice: instead of remaining in Paris with her thriving studio and Atget's increasingly fashionable pictures, she returned to the United States, where she gradually gave up portraiture, having decided, in 1929, to make a photographic record of New York City. At the same time, Abbott rejected Surrealist notions of Atget's photography. In her first article about him, in 1929, she emblazoned the opening page with one of the images that Surrealists loved, a circus facade with rearing horses, photographed extremely off-center (fig. 81). But in her text Abbott defiantly ignored the fantastic quality of this and other photographs and ascribed to Atget the documentary purpose she had set for herself: "How can anybody but a photographer hope today to fix for posterity the image of the modern city?"[67] Moreover, Abbott called Atget an artist in this essay, and she cast him

81. *Vaugirard Street Fair*, 1913
Gelatin silver chloride print. Atget
negative number 409 (Picturesque
Paris, Part II)
Inscribed on mount verso: *Fete de
Vaugirard*
The Lynne and Harold Honick-
man Gift of the Julien Levy
Collection, 2001-62-392

as one for a distinctly American sensibility. Consider her words about the cot-
ton gin and the tomato—quoted at the beginning of this essay—to describe the
wonder of his photographs: the cotton gin and the tomato as opposed to the
umbrella and the sewing machine, one might add. The latter odd couple would
become Surrealism's cliché, a crib note on its weird juxtapositions of incongru-
ous things. Abbott's choice of objects set Atget on a different course, one in
which familiar things are revealed in a new light, but only to throw clarity on
their objective possibilities, not their subjective affinities. The other nineteenth-
century photographers Abbott would claim and promote as her photographic
forebears—Nadar, Mathew Brady, William Henry Jackson—firmly placed At-
get (and Abbott) in a pantheon of objective documentation, cast by its Ameri-
can adherents as a new form of art.[68]

Upon her return to New York, Abbott turned her own cameras toward the
city. She conceived of her photographs of New York as a cumulative, compos-
ite portrait. They are unified by that sense and are in that light clearly moti-
vated by Atget's body of Paris work. But Abbott's photographic techniques
are diverse. For her, recording the modern city evidently involved using all
the photographic means at her disposal. When she used a handheld camera, for
instance, she took every advantage of its possibilities for angled snapshots—a

superb way to record New York's skyscrapers. When she used a view camera, somewhat like Atget's, she typically made carefully structured views, which in their wide field of vision, unified composition, and single purpose are equally different from Atget's photographs. (An Abbott view is usually a record *as such*, made to satisfy her own criteria as opposed to the interests of any client.) But sometimes Abbott made startling references to Atget's work, as if she had come across a memory of one or several of his photographs. In her 1937 New York photograph *Kosher Chicken Market, 55 Hester Street*, Abbott structures the view of the shop front much as Atget might have done (fig. 82). The facade is on a slight axis, and various elements secure the picture's edges. The birds in the window recall Atget's view of a game vendor's market stall, a negative from which Abbott had made prints (fig. 83). And the young man standing in the light and shadows of the interior, his face half lost behind the bird rack, recalls countless wispy figures who almost hide in Atget's photographs (see fig. 70).

Julien Levy, in contrast to Abbott, embraced Surrealism in 1927 and did not let it go. If we look at certain Atgets from his collection, generally those we cannot trace to the paper workroom albums Levy owned, we see a couple of patterns. Levy tracked Man Ray's Atget selections, and he augmented them with another group ripe for a Surrealist point of view: Atget's 1920s photographs of French parks, especially Versailles. This is not surprising; Levy was

LEFT:
82. Berenice Abbott (American, 1898–1991)
Kosher Chicken Market, 55 Hester Street, 1937
Gelatin silver print: image and sheet, 9½ x 7⁹⁄₁₆
inches (24.1 x 19.2 cm); mount, 13⁹⁄₁₆ x 10⅜
inches (34.4 x 26.4 cm)
Gift of E. M. Benson (1945), 2003-97-1

RIGHT:
83. *Shop, Les Halles*, 1899–1900.
Printed by Berenice Abbott, c. 1930
Gelatin silver print. Atget negative number 357
(Picturesque Paris, Part II); formerly Atget
negative number 3270 (Picturesque Paris, Part I)
Inscribed (by Abbott) on mount verso: *Boutique*
The Lynne and Harold Honickman Gift of the
Julien Levy Collection, 2001-62-320

84. *Invalides Street Fair*, 1900
Albumen silver print. Atget nega-
tive number 3102 (Picturesque
Paris, Part I)
The Lynne and Harold Honick-
man Gift of the Julien Levy
Collection, 2001-62-312

Man Ray's acolyte. At twenty-one, young Julien had fallen, with remarkable
ease, into the most accomplished bohemian circles. The year he came to Paris
with Duchamp to meet Man Ray, he fell in love with and married Joella Loy,
daughter of Mina, whom Julien also lionized; James Joyce and Constantin
Brancusi were the invited witnesses to the marriage. Asked about these con-
nections years later, Levy said: "I had two very definite impressions and they
were both somewhat mystic. Number one, I felt as though I'd found where I
belonged, so I was not surprised at all. And, number two, I was full of hero
worship which I didn't lose."[69] Inversely to Abbott, Levy made his enthusiasm
for Atget his engine *into* the Surrealist avant-garde, not away from it. It is also
not surprising, then, that instead of buying fifty Atgets, as Man Ray did, Levy
bought several hundred.[70]

Levy used his found objects well. In all of Atget's work there are many in-
stances of each kind of subject he photographed, including the ones Surrealists
loved: phalanxes of turned backs (fig. 84; see also fig. 64); crowded shop win-
dows and empty stages, photographed from very low, or at an angle (figs. 85,
86); empty staircases, photographed to record the metalwork and the design of
the space, but pregnant with mystery for the uninitiated (fig. 87); ragpickers,
the urban figures who seemed to twist logic into knots, so complete was their

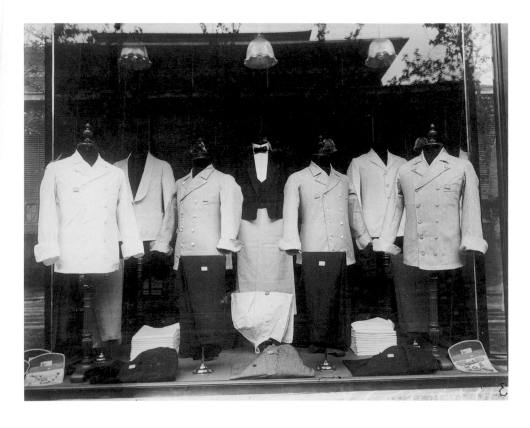

85. *Shop, Les Halles*, 1925
Gelatin silver chloride print. Atget negative
number 93 (Picturesque Paris, Part III)
Inscribed on verso: *Les Halles*
The Lynne and Harold Honickman Gift of the
Julien Levy Collection, 2001-62-164

86. *Boulevard de la Villette*, 1924–25
Gelatin silver chloride print. Atget negative
number 48 (Picturesque Paris, Part III)
Inscribed (by Abbott) on mount verso:
Boutique / Bd de la Villette
The Lynne and Harold Honickman Gift of the
Julien Levy Collection, 2001-62-64

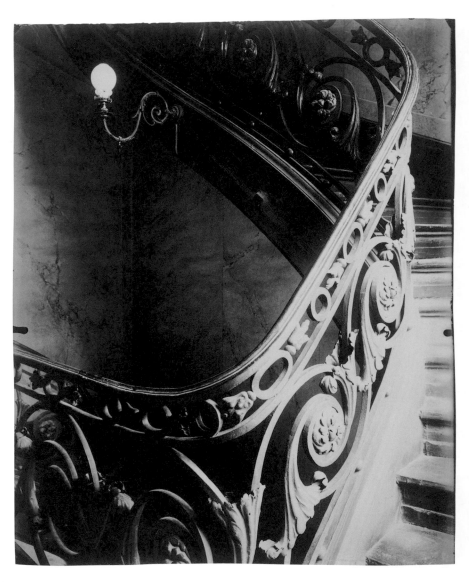

87. *Hôtel de Sully-Charost, 11, rue du Cherche-Midi*, 1904–5
Albumen silver print. Atget negative number 4958 (Art in Old Paris)
Inscribed on verso: *Hotel de Sully charost / 11 Rue du cherche Midi*
The Lynne and Harold Honickman Gift of the Julien Levy Collection, 2001-62-85

own economy (figs. 88–90). Levy collected these. He even found one Atget unlike anything Man Ray had: a view of a Baroque doorway in Rouen, which due to some accidental slippage during exposure shows the whole thing in triplicate (fig. 91). Atget took his camera to Rouen only once, in 1907, and presumably when he discovered the misexposure, he decided the subject was important enough and the details clear enough to keep it. A librarian at the Bibliothèque des Arts Décoratifs in Paris must have agreed—a print of the photograph is in its collection.[71] But for Levy this was a Surrealist's prize; on its verso is the inscription "Atget / unique," as if to ensure that among his hundreds of Atgets this one would be treated with due care.

Levy also collected pictures to fashion his autobiography—revelatory subjects to illustrate his life as he imagined it. He found multiple Atgets depicting

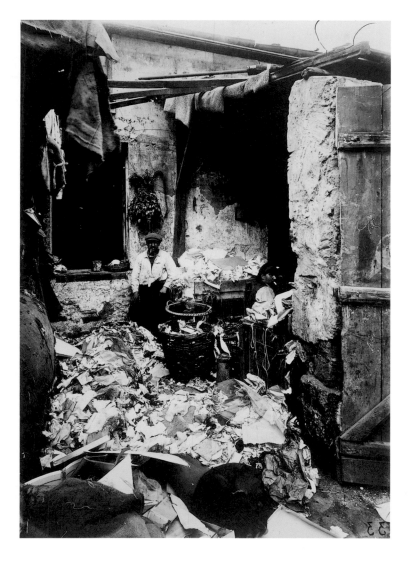

88. *Ragpicker, Asnières Gate, Trébert City,* 1913
Printed by Berenice Abbott, c. 1930
Gelatin silver print. Atget negative number 433
(Picturesque Paris, Part II)
The Lynne and Harold Honickman Gift of the Julien
Levy Collection, 2001-62-360

89. *Ragpickers, Choisy Gate, Fortifications Zone,* 1913
Albumen silver print. Atget negative number 408
(Picturesque Paris, Part II)
Inscribed (by Abbott) on mount verso: *Porte de Choisy*
The Lynne and Harold Honickman Gift of the Julien
Levy Collection, 2001-62-185

90. *House of a Ragpicker, Montreuil Gate, Fortifications Zone*, c. 1910
Gelatin silver chloride print. Atget negative number 347 (Picturesque Paris, Part II);
formerly Atget negative number 123 (Picturesque Paris, Part II / Zoniers)
Inscribed (by Abbott) on mount verso: *Porte de Montreuil*
The Lynne and Harold Honickman Gift of the Julien Levy Collection, 2001-62-187

91. *Rouen,* 1907
Albumen silver print. Atget negative number 316 (Landscape-Documents / Rouen)
Inscribed on verso: *Rouen-*
The Lynne and Harold Honickman Gift of the Julien Levy Collection, 2001-62-189

fauns and satyrs (figs. 92, 93), as well as two photographs of the church of Saint-Julien-le-pauvre. One of these is a quite phallic record of a medieval column and capital (fig. 94). The other one, interestingly enough, is an example of Atget's copy work. Often he would re-photograph one of his own pictures, typically to make a smaller detail the subject of the new photograph. It is not clear why Atget did this with the view of the church interior, but the doubled negative clips at the right edge and the first print's visible top edge give it away (fig. 95). Levy treated his two pictures of Saint-Julien-le-pauvre alike, inscribing his initials and an inventory number on the verso of both. Many photographs in the Julien Levy Collection have such markings, typically to identify prints Levy chose to reserve from a larger selection. It seems Levy sought to find himself inscribed in these pictures of his namesake church; if so, he was simply putting an additional slant on his found objects. The Surrealist delight in objective chance extended

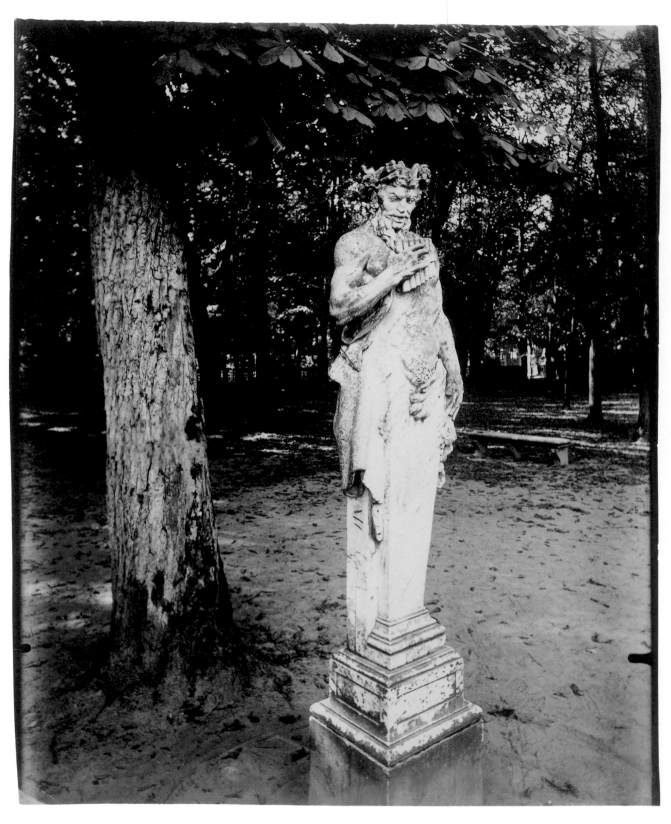

92. *Versailles—Faun,* 1921–22
Albumen silver print. Atget negative number 1101 (Versailles or Landscape-Documents / Mixed Documents)
Inscribed on the verso: *Versailles—Faune*
The Lynne and Harold Honickman Gift of the Julien Levy Collection, 2001-62-267

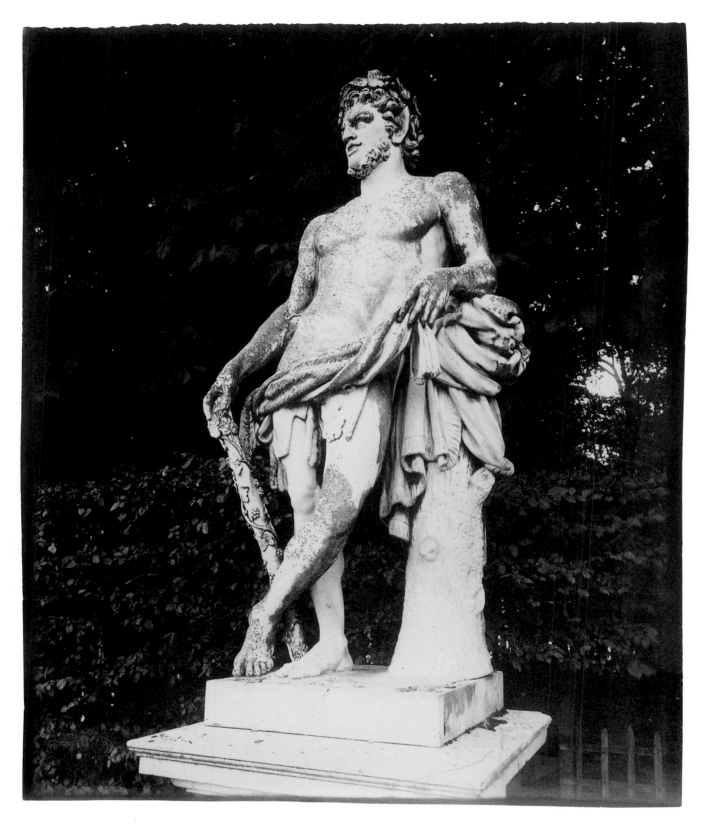

93. *Versailles — The Satiric Poem*, 1923–24
Albumen silver print. Atget negative number 1219 (Versailles)
Inscribed on verso: *Versailles / Le Poeme Satirique*
The Lynne and Harold Honickman Gift of the Julien Levy Collection, 2001-62-268

94. *Church of Saint-Julien-le-pauvre*, 1903–4
Albumen silver print. Atget negative number 4826 (Art in Old Paris)
Inscribed on verso: *St Julien le Pauvre*
The Lynne and Harold Honickman Gift of the Julien Levy Collection,
2001-62-196

95. *Church of Saint-Julien-le-pauvre*, 1922
Gelatin silver chloride print. Atget negative number 6339 (Art in Old Paris)
Inscribed on verso: *St. Julien le Pauvre*
The Lynne and Harold Honickman Gift of the Julien Levy Collection,
2001-62-197

to coincidence, and it could apply to one's fate as easily as one's desire—there is seduction in both.[72]

Again like Man Ray, but more so, Levy was a connoisseur of Atget's prostitute pictures. In 1921, and again in 1925, Atget made photographs of women stationed for business outside their doorways, some additional views of unpopulated brothel facades, and a handful of nudes; altogether, there are about fifteen pictures, but today half of them are among Atget's most famous. The Cubist painter and illustrator André Dignimont (1891–1965), a collector of pornography and erotica, commissioned Atget to make at least some of these photographs for a book about Parisian prostitutes.[73] Whether at Dignimont's behest or by Atget's prerogative, most of the photographs include a generous amount of setting. The brothel facades (fig. 96) look very much like his other architectural records, and the women (figs. 97–100) are more or less updated examples of the photographs he made of other street trades early in his career (see figs. 6, 7). As with those earlier pictures, there is sex in these: open doorways, frank gazes, white socks and a fur stole. The women obviously agreed to the photographs—they were probably paid for them—and Atget gave them as

96. *10, rue Mazet*, 1925
Gelatin silver chloride print. Atget negative number 86 (Picturesque Paris, Part III)
Inscribed on verso: *10 Rue Mazet*
The Lynne and Harold Honickman Gift of the Julien Levy Collection, 2001-62-47

much of a stage as he ever gave any figure in his work. Looking at their poses and expressions, it is easy to imagine that both photographer and subjects valued the exchange.

Two of the prostitute photographs (both unique prints, apparently) depict a nude woman on a divan—a bed of flowers, it so happens—with tiny cupids in attendance on the wall. Man Ray owned one of these, Levy the other.[74] In Man Ray's photograph the woman lies with her back to the camera, her face hidden—so hidden, in fact, that her body looks headless (fig. 101). The left edge of the photograph crops the figure's legs as decisively as the shadows on the right take her head, leaving her bottom and thighs the disembodied subject of the view. Whatever Atget's intentions, this picture enacts the kind of disfiguration seen over and over in Surrealist photographs of the female nude, in which distortion of form is pushed to extreme ambiguity—formlessness, to use a Surrealist's word.[75] Man Ray experimented with such visual mutation of the female form in photographs well before he found Atget's work, yet it is possible that this picture, with its abrupt cropping and its layering of form with pattern, was one that had real influence on his practice (fig. 102).

97. *Prostitute on Her Shift, rue Asselin, La Villette,* 1921
Gelatin silver chloride print. Atget negative number 12 (Picturesque Paris, Part III)
Inscribed (by Abbott) on mount verso: *Rue Asselin*
Gift of Carl Zigrosser, 1953-64-29

98. *Prostitute on Her Shift in Front of Her Doorway, rue Asselin, La Villette, March 7, 1921*, 1921
Printed by Berenice Abbott, c. 1930
Gelatin silver print. Atget negative number 6218 (Art in Old Paris)
Inscribed on mount verso: *Cabaret*
The Lynne and Harold Honickman Gift of the Julien Levy Collection, 2001-62-324

99. *Rue Asselin*, 1924–25. Printed by Berenice Abbott, c. 1930
Gelatin silver print. Atget negative number 47 (Picturesque Paris,
Part III)
Inscribed (by Abbott) on mount verso: *Cabarets*
The Lynne and Harold Honickman Gift of the Julien Levy
Collection, 2001-62-325

100. *Brothel, Versailles, Petite Place, March 1921*, 1921
Printed by Berenice Abbott, c. 1930
Gelatin silver print. Atget negative number 11 (Picturesque Paris,
Part III)
Inscribed (by Abbott) on mount verso: *Maison Close*
The Lynne and Harold Honickman Gift of the Julien Levy
Collection, 2001-62-349

Levy's nude, on the other hand, has an equally unsettling but completely op-
posite effect (fig. 103). Here the subject (it is impossible to say if she is the same
model) lies on her back and gazes listlessly away, her entire body on display.
The room plays a larger role in this photograph, but the setting's playful deca-
dence jars with the pallid, vacant figure. Very little about this proffered com-
panion is appealing—not her uncomfortable pose, not her over-lit, washed-out
flesh, not her dirty foot. Perhaps Atget made other photographs like these and
destroyed them. But compared to the documents of women in doorways, these
boudoir scenes flag.[76] No matter that Atget set the putti and the pillows and the
gilded frame to work, naked pictures were not his forte.

Around the time that Atget made these pictures, he also made copy pho-
tographs of female nudes by other photographers. Presumably he wanted a
stock of such work (maybe Dignimont's business gave him the impetus), and
he found it simpler or more agreeable to make new negatives of pictures picked
up wherever.[77] He made more than a dozen such copies; Man Ray owned three
of them.[78] Levy was luckier. Atget, it appears, gave him one of the "originals," a
little print of a topless lady, her arms stretched behind her head to better display

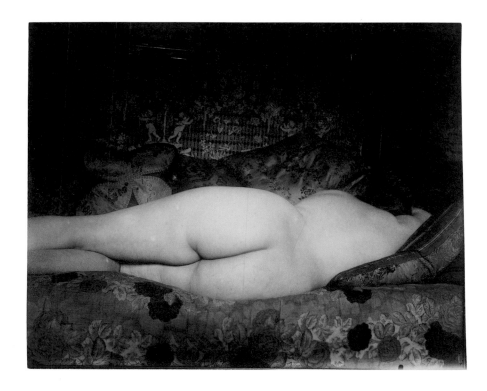

101. *Woman*, 1925–26
Matte albumen print. Atget negative number 62
(Picturesque Paris, Part III)
George Eastman House, Rochester, New York

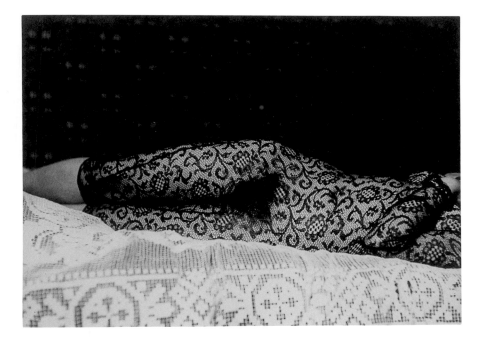

102. Man Ray (American, 1890–1976)
Untitled, c. 1930
Gelatin silver print; 6¼ x 8¾ inches (15.9 x
22.2 cm)
From the collection of Thomas H. Lee and
Ann Tenenbaum

her full breasts (fig. 104).[79] This model is more engaging than Atget's: she gazes
back. Her almost-smile and her welcoming pose give the photograph a sexy
complexion. But the interest of this photograph, as of some others, is what Levy
made of it. On the back someone has written: "From Atget Julien suspected it
was the woman he lived with."

Levy liked to speculate. Like a good Surrealist, he wanted sex to crop up
wherever it may. And he was fascinated by the idea of Valentine, the companion
whom Atget lived with but never married (that is the part that titillated Julien—

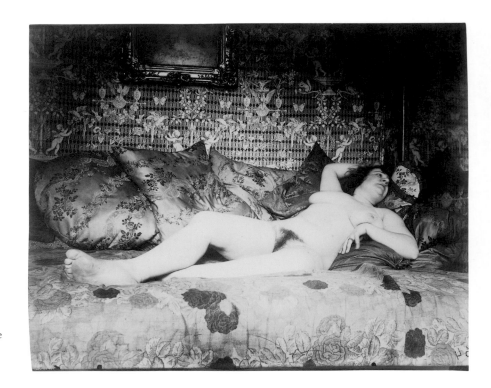

103. *Woman*, 1925
Gelatin silver chloride print. Atget negative
number 64 (Picturesque Paris, Part III)
Inscribed on verso: *Femme*
The Lynne and Harold Honickman Gift of the
Julien Levy Collection, 2001-62-80

as if a wife with whom one were always misbehaving was some kind of dream).
Valentine, never named, nonetheless receives three mentions in Levy's memoir,
in the six pages he devotes to Atget: "He left the sea to become a bit-part actor
touring the provinces. It was then he acquired his *amie*, a constant companion of
the theater years. Ten years his senior, she became his mistress and wished him
to live with her in a more or less *serieux* way."[80] Levy romanticized Atget, some-
what as he did his avant-garde heroes—Duchamp, Man Ray, Mina Loy, and
others. On the boat to Europe in 1927, Duchamp told Levy about his idea for a
lady mannequin made of wire, a "mechanical female apparatus," which would
be a self-lubricating masturbation machine. Levy contributed a modification:
the doll could be "activated" by a mouth-to-mouth kiss. Levy later recalled: "It
was then that Marcel unbent, giggled for the first time, and admitted me to his
inner circle of intimate friends." In his reminiscence of Atget, Levy made the
photographer into a similar artist/seducer. Writing about the emptiness that
characterizes some of Atget's photographs, he called it "a concentrate of that
spirit that was Atget's own, like the love he had spent living with his model until
the second when his shutter sprang to grasp her one last time."[81]

We are quite far here from Atget's own view of his photographs. Of course,
he never tried to account for the gaps or empty spaces or strange conjunctions
in them. But the differences between Atget and Levy do not reside solely in
Atget's professional knowledge of his work. Nesbit has written about Atget's
stubborn insistence on his own version of modernity, which did not take Paris to
be the locus of fashionable life, the place for pretty ladies and *objets de luxe* and
grand boulevard manners, but rather took the city as an enormous fact of mod-
ern life—not something produced for easy consumption (by young foreigners,
among others), not something produced exclusively by or for the bourgeoisie.

Atget refused to give that class the city in its own image.[82] His ragpickers are not romantic human ruins, nor are they philosophers. His prostitutes are not dangerously seductive, nor are they fallen women. They all have business to attend to. What has this to do with Julien's fantasies about Valentine? For Levy, being modern, being a Surrealist, being avant-garde, being *not* bourgeois, all turned on sex. For Atget, as far as his photography went (and we must remember that we know little else about him), sex seems to have been one more fact to put in a document. In any event, it was not the crux of his photographs.

Berenice Abbott never remarked on Atget's nudes. Clearly she valued his other prostitute pictures, because she published them and made exhibition prints from many of the negatives. Unlike Levy, Abbott did not speculate. In 1928 she asked André Calmettes to provide a biography of his friend Atget. He replied with a letter containing the few facts he knew about the man and several warm observations. Abbott quoted and paraphrased these reminiscences for the next forty years, and there her musings about Eugène Atget the private man began and ended. Her investment in Atget was of a different order than Levy's, but it was if anything more intense and more personal. It is hard to find a similar example of one artist spending so much of her life and career conserving and promoting the work of another. In 1956 Abbott produced a centennial portfolio of prints from twenty of Atget's negatives, and in 1964 the Horizon Press published her largest book, *The World of Atget*, with many illustrations and an essay by Abbott. Its title is surely meant to communicate the great scope Abbott saw in Atget's photography, and that is where Abbott's own take on Atget and modernity comes in.

Like Atget, but more so, Abbott made self-effacement a principle in her work. Her personal life never enters a photograph or a text. This was perhaps necessary in Abbott's time and place—she was romantically involved with women throughout her life, and soon after her return to the United States she began a lifelong relationship with the writer and critic Elizabeth McCausland. But personal matters aside, Abbott's self-effacement surely reflects her modern sensibility. Like Levy, she thought photography was the great modernist medium, but Abbott thought so because of its objectivity. In 1951 she described the modern photographer: "I believe the true photographer is a curiously odd type of species, not easy to define, but his photographic gift is a highly charged and trained vision. This vision is focused, by the nature of the medium, on the here and now."[83] Earlier in the article she wrote: "If a medium is representational by nature of the realistic image formed by a lens, I see no reason why we should stand on our heads to distort that function. On the contrary, we should take hold of that very quality, make use of it, and explore it to the fullest."[84] Little wonder Abbott found the Surrealists' enthusiasm for Atget so foreign to her own.

Levy's Surrealism

It is easy to treat Levy's response to this or that Atget photograph lightly. His collector's passion is utterly different from Atget's methodical relationship to his own work, and it is often just as far from Abbott's serious reverence. But Levy's Surrealism took in several things. For we must acknowledge, looking at

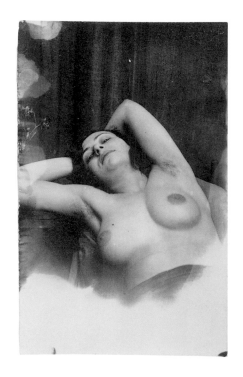

104. Photographer unknown
Untitled (Nude torso of a woman), c. 1900–1925
Gelatin silver print; image and sheet 3 15/16 x 2 7/16 inches (10 x 6.2 cm)
Inscribed on verso: *from AtGet / Julien / suspected it / was the / woman he / lived with.*
The Lynne and Harold Honickman Gift of the Julien Levy Collection, 2001-62-1334

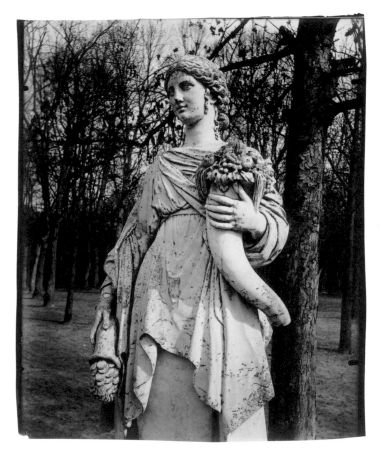

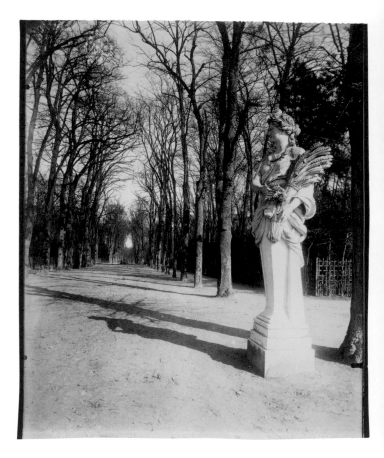

105. *Versailles*, 1922
Albumen silver print. Atget negative number 1118 (Versailles or Landscape-
Documents / Mixed Documents)
Inscribed on verso: *Versailles*
The Lynne and Harold Honickman Gift of the Julien Levy Collection,
2001-62-278

106. *Versailles*, c. 1922
Albumen silver print. Atget negative number 1141 (Versailles or Landscape-
Documents / Mixed Documents)
Inscribed on verso: *Versailles*
The Lynne and Harold Honickman Gift of the Julien Levy Collection,
2001-62-281

Atget's photographs, that numerous among them are marvelous and strange.
The critic and historian Rosalind Krauss has described the bond between Sur-
realism and photography: a photograph is a visual slice of the world, but one
that has been selected. That act of selection—the simple framing of a view—is
comparable to any other act of representation. Wedded to it, however, like the
flip side of a coin, is reality, tenaciously holding on at the heart of the image.
The result sometimes looks like a cousin to Surrealist acts of automatism: an
image (in photography's case) that almost skirts representation. That is the
source of the frisson. Consider Atget's battalion of co-conspirators, his gestur-
ing sculptures and pointing statuettes and laughing visages. In every instance
it is Atget's act of framing that gives them the animated roles they play within
their photographs (figs. 105–8). Yet it is the figures' real existence in the world
that gives the photographs their dreamlike—or haunted—quality.

Atget and the Surrealists shared more than photography. The poet Robert
Desnos wrote about the statues of Paris, claiming that the heaviness of bronze
and marble made sculpture a poor vehicle for modern symbolism (he fantasized

107. *Trianon — The Buffet,* c. 1922
Albumen silver print. Atget negative number
1126 (Versailles or Landscape-Documents /
Mixed Documents)
Inscribed on verso: *Trianon — Le Buffet*
The Lynne and Harold Honickman Gift of
the Julien Levy Collection, 2001-62-201

monuments to the subjects of advertising billboards). Still, Desnos could not let
go of statues' "magical" lives, the idea that human simulacra have an existence
of their own. But over marble monuments to dead men he preferred the popular
effigies at the Musée Grevin, a wax museum, and the mannequins in Parisian
store windows.[85]

Surrealists mined the tension between the photograph and the world with
a variety of strategies. Many are specific to Surrealism, but the most pervasive
one is a tactic we see often in Atget's photographs: doubling. According to
Krauss, photographic doubling, like the photographer's act of framing, gives us
reality constituted as a sign, as representation.[86] To double is to repeat, to pair
something with its twin, its echo, its reflection, or its shadow. In photographs,
doubling can disrupt a seamless slice of reality, sewing it with repetitions that
confound any rational sense of space and time, of original and copy, like a hall
of mirrors. Now, Atget was no Surrealist. His photographs are full of reflec-
tions and shadows and paired objects, but always — always — in the interest of
more fully describing a space or the physical relations between things. That is

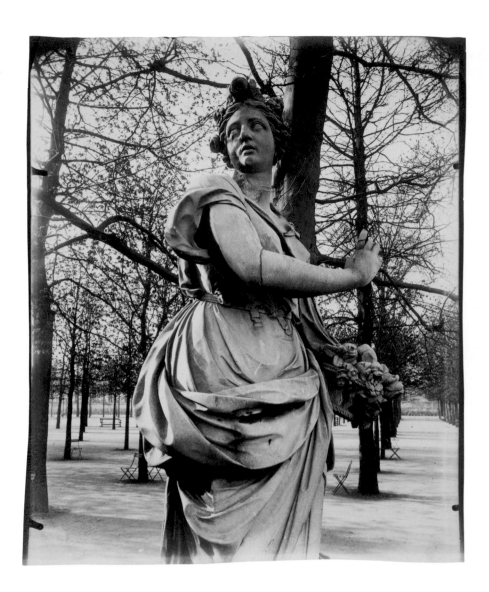

108. *Tuileries Gardens—Figure*, 1921
Albumen silver print. Atget negative number
6234 (Art in Old Paris)
Inscribed on verso: *Tuileries—Figure*
The Lynne and Harold Honickman Gift of
the Julien Levy Collection, 2001-62-211

not to say Atget did not enjoy the complications. A 1907 or 1908 view of the
Louvre stretches the palace out on top of its reflection (fig. 109). The view-
point makes the building strangely small, and the reflection makes an inkblot
of its grandeur, somewhat like the view of the staircase at the Parterre du Nord
(see fig. 61). Another photograph, made in the Luxembourg Gardens in 1901 or
1902, puts a man on a park bench amidst an endless regression of sculptures and
tree trunks. The sculptures are the queens of France. Marguerite of Provence,
the purported subject of the view (if we follow Atget's inscription), appears to
sprout an armor of neatly hedged branches (fig. 110). What are we to make of
these doublings? Again and again, such devices in Atget's photographs juxta-
pose the subject—a palace, a statue of a queen, mannequins in a window—and
its context, so that the two pull each other apart a little bit, to the effect that past
and present, grand ideas and daily circumstances, one version of things and
another version of them, are all let into the picture.

It is useful to consider another mode of doubling that runs through At-
get's work, although to call it doubling is a stretch. Like any good document

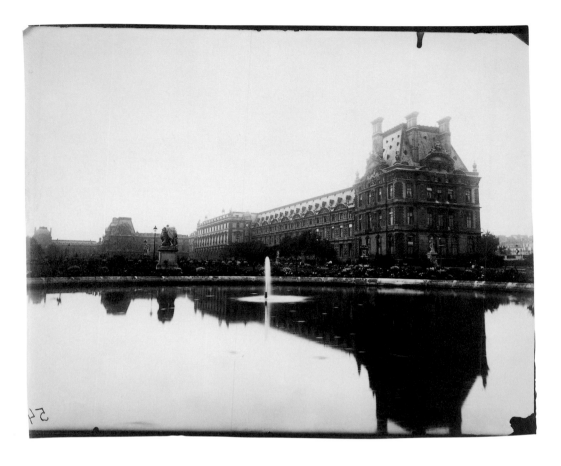

109. *Tuileries Gardens*, 1907–8
Albumen silver print. Atget negative
number 5487 (Art in Old Paris)
Inscribed on verso: *Tuileries*
The Lynne and Harold Honickman Gift of
the Julien Levy Collection, 2001-62-226

photographer, Atget often made multiple views of a single subject. Three views
of one sculpture in the Tuileries Gardens, made in 1903, exemplify his thorough-
going approach (figs. 111–13). Sometimes Atget also made two views of the
same subject or motif that are so alike as to constitute something akin to a dou-
bled picture. Several pairs of photographs in his public album of interiors are
like this: the two views of the same corner in his own small salon (see figs. 46,
47) and a pair of views of two different places in Cécile Sorel's apartment (see
figs. 33, 34), which mimic each other in their arrangement, are good examples.
This mimicry confers nothing uncanny or strange on its subjects. In the case of
Sorel's apartment it highlights the slight ridiculousness of her antiques propped
on stages and the slight mania of her symmetrical decorating schemes. This sort
of doubling serves to clarify a subject and underscore the contingent nature of
looking at anything, how one's comprehension of a thing changes—sometimes
subtly—with point of view or context. It depends on close, thoughtful look-
ing (the kind for which Atget designed his public albums), what is best called
a reading of photographs—that is, considering the pictures in relation to each
other, to their subjects, and to many other experiences.[87]

In 1925 Atget photographed in the park of Sceaux. This was an ancien régime
terrain, like Versailles or Saint-Cloud, but it was in ruins. The park had only
come into the public domain the previous year.[88] Atget must have been excited
by the prospect of such a big new subject; he began a series devoted to Sceaux,
and over several months he made sixty-five views of the park. The only pho-
tograph from this series in the Julien Levy Collection was made in the month

110. *Luxembourg Gardens — Marguerite of Provence,*
1901–2
Albumen silver print. Atget negative number 4440
(Art in Old Paris)
Inscribed on verso: *Jardin Luxembourg. / Marguerite
de Provence*
The Lynne and Harold Honickman Gift of the Julien
Levy Collection, 2001-62-145

of March and records a sculpture of Vertumnus, Roman god of the changing
seasons, here depicted at the moment when, disguised as an old woman, he re-
moves his mask and hood to reveal himself as a beautiful youth to Pomona, the
object of his desire (fig. 114). In Atget's photograph, the statue seems to lead a
single-file troop of slightly tipsy marble urns; their purpose is no longer clear,
although they do visually link the foreground to a passage through the trees at
the far end of the field. (In the left distance, at the edge of the trees, two more
statues stand sentinel for another lost purpose.) Here again Atget has put a view
to work describing topography, although it is hard for the statues and vases to
do that work, so successfully has nature reasserted itself. Following his well-
established practice, Atget photographed the sculpture against a backdrop of
foliage. He also photographed facing the sun, so that bursts of light filter through
the trees and the area of open sky is a bright wash, producing a halo of sorts at
the tree line and around the largest branches in the foreground. This is a gelatin
silver chloride print, and like many of Atget's others it has suffered over time:
its left edge bears a pattern of fading, although the image is still visible there.

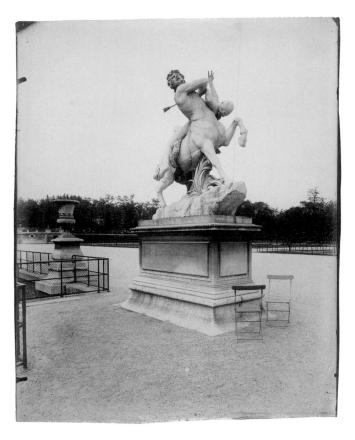

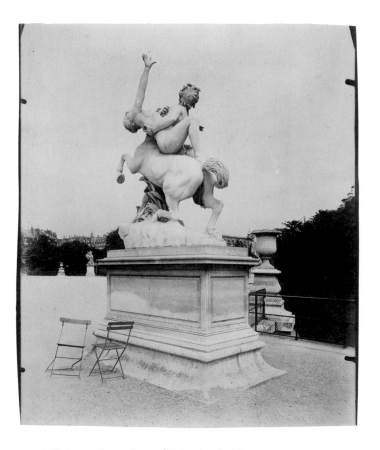

111. *Tuileries Gardens—Rape of Deianeira, by Marqueste*, 1903
Albumen silver print. Atget negative number 4709 (Art in Old Paris)
Inscribed on verso: *Les Tuileries*
The Lynne and Harold Honickman Gift of the Julien Levy Collection,
2001-62-152

112. *Tuileries Gardens—Rape of Deianeira, by Marqueste*, 1903
Albumen silver print. Atget negative number 4734 (Art in Old Paris)
Inscribed on verso: *Jardin des Tuileries—/ Er.lévement de Déjanire / par
Marqueste*
The Lynne and Harold Honickman Gift of the Julien Levy Collection,
2001-62-126

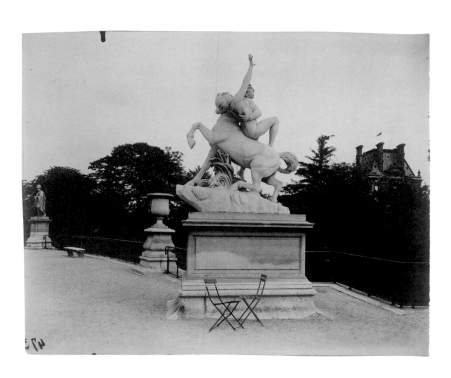

113. *Tuileries Gardens—Rape of Deianeira, by Marqueste*, 1903
Albumen silver print. Atget negative number 4735
(Art in Old Paris)
Inscribed on verso: *Jardin des Tuileries—/ Enlévement de
Déjanire / par Marqueste*
The Lynne and Harold Honickman Gift of the Julien Levy
Collection, 2001-62-127

114. *Sceaux, March, 7:00 Morning,* 1925
Gelatin silver chloride print. Atget
negative number 18 (Sceaux)
Inscribed on verso: *Sceaux*
The Lynne and Harold Honickman Gift
of the Julien Levy Collection,
2001-62-192

The effect of the fading is oddly reminiscent of the washed-out sky at right. The statue, fractured with age and ruin, seems to respond to the strange light and half-cover of trees with his gesture and his address to the beholder. Surrealists valued photography for this ability to present the natural as the constructed—to offer up the world, in the words of André Breton, as "a forest of signs."[89] Like Surrealist photographers, Atget employed all of the medium's formal means. The results, especially when looking at single pictures like this one, often come close to Breton's description.

In his 1936 book *Surrealism*, Levy wrote: "SURREALISM is a point of view, and as such applies to Painting, Literature, PLAY, BEHAVIOUR, POLITICS, ARCHITECTURE, PHOTOGRAPHY, and CINEMA."[90] Levy's description follows other, more authoritative ones—his book's purpose was to introduce an American audience to the European movement—but he privileged photography more than most writers. The photography section of the book commences with Atget's oneiric record of a corset shop window (see fig. 66). Levy wrote respectfully—obliquely—about this, not treading too harshly on Abbott's ideas or on what he knew of Atget himself: "He photographed the palace and the hovel with the lens of reality but also with a sense surpassing reality."[91] Images by Man

Ray, Hans Bellmer, and Henri Cartier-Bresson follow, along with an earlier text of Levy's on Cartier-Bresson, in which he tested many terms to get at the nature of that work: *crude, septic, profane, accidental, anti-graphic*. In the context of his Surrealism book, it seems Levy meant the words not just for the works of Cartier-Bresson he illustrated, but for any photograph with a Surrealist "point of view," and in opposition to the elegant art photography of the day, which insisted on the fine photographic print and elevated subject matter (be it only the expression of the artist's sensibility in the face of worldly detritus). Here, Levy identifies such work with "the great S's of American photography" — Stieglitz, Steichen, Strand, Sheeler. Why place Atget in opposition to these figures? In other contexts Levy championed their work, and he was proud that when he showed Stieglitz Atget's photographs, Stieglitz agreed that Atget was "one of the greats."[92] (Throughout his life Levy claimed Duchamp and Stieglitz — polar opposites of modernism — as his intellectual godfathers.) As we have seen, Levy delighted in Atget's own prints. But there was no denying — Abbott and Levy both knew it — that Atget's prints were not the endpoint of his work. He made them to be used by others. They were never, in any case, aesthetic objects. Nor are Atget's motifs. He found amazing creations — somebody's ornamented bedroom wall, a ragpicker's hut with an ivy trellis and two stuffed goats on the roof — but he did not make things picturesque; he did not prettify the crude, the septic, the profane.

Levy and Abbott shared this sentiment about photographic prints: elegant ones were superb things, but they were hardly a litmus test for good photography. Writing about Atget's prints and others, Abbott consistently decried the "artiness" of the American photography establishment.[93] If Abbott aestheticized Atget's photography at the same time she insisted on its workmanlike qualities, Levy presented it as more than the edgy instance of a Surrealist "point of view." In another 1930 letter to Mina Loy, Levy excitedly catalogued Atget's subjects: "You remember the photos? Of every conceivable subject in or around Paris, doorways, stairways, brothels, courts, trees, street vendors, fairs, shop windows, corsets and umbrellas. All taken with beautiful quality, selection, and composition."[94] Surrealist subjects have their play in this list, but Levy's point is Atget's wide documentary scope. Here is one of the most engaging aspects of Levy's involvement with photography in the 1930s and afterward: he was resolutely undogmatic about what the medium was for, how photographs should be viewed, where they should be displayed. We see this in his own Atget photographs, which range from beautiful prints he collected like a connoisseur, to "Surrealist" oddities acquired no doubt with his heroes in mind, to banal copy work coveted for the most personal of reasons. Consider too Levy's exhibitions of Atget's work. In 1931, shortly after the Julien Levy Gallery's debut exhibition of a broad range of American photography, Levy held a joint show of work by Atget and Nadar. Each was presented as a historical "master," with a gallery to himself. But while vintage prints were exhibited on the walls, each gallery held racks of "reprints" for sale (made from the photographers' negatives by Abbott and by Nadar's son, Paul). Immediately following, in January 1932, Levy mounted his storied first exhibition of Surrealism, with Atget photographs featured alongside a hodgepodge of European and American contributions to

the movement, including paintings by Salvador Dalí and Max Ernst, objects by Joseph Cornell, and photographs by Man Ray, Roger Parry, and George Platt Lynes, among many other things. In 1936, together with an exhibition titled *Modern Photography*, Levy mounted a one-man show, *Photographs by Eugène Atget, An Epoch of Contrasts: Paris Chateaux, Chiffoneries, Petites Métiers* [sic]. If together these displays add up to a confusing view of Atget, they have the real virtue of not pinning the work down very neatly. Photography—Atget's and everybody else's—found breathing room in the Julien Levy Gallery, where it was presented as the ubiquitous modern medium, to be treated absolutely seriously and taken for granted, all at once.

In 1930, in Abbott's book *Atget Photographe de Paris*, Pierre Mac Orlan wrote about Atget: "he knew how to recognize in every thing the nuance that gave that thing its value."[95] The Julien Levy Collection includes a photograph by Atget of lilies, made either in the beginning of his career, before 1900, or during the years of World War I, when he photographed very little (fig. 115). This is one of the prints Abbott mounted for exhibition around 1930; it is on the thick gelatin silver chloride paper that was frequently the site of printing errors by Atget, like the ones visible here: two yellowed blots at the bottom of the print and a larger, less noticeable patch of fading right at the center.[96] Here is another case where the mistakes in Atget's print seem to cooperate with his subject; it is as if the lilies' sticky sweetness and messy pollen have spread, polluting the print itself. This is a typical plant study for Atget: several flowers in close detail, grounded by a blurry but useful view of many more lilies, in a standard formation. Atget's negative bag sits on the grass, perhaps unintentionally, but it forms a spot of darker ground against which to study one blossom. Yet again we could enumerate the types of designer who would happily buy this picture. What is amazing about the photograph, though, is the way the flowers loom. Atget placed himself almost underneath them, and in so doing he caught the whole experience of these lilies—their intoxicating scent; the way they dominate their stalks, leaning forward with the weight of pollen and moisture; the sweet rottenness of their dying blooms, so redolent of heavy summer.

Atget made the qualities of his subjects startlingly evident. That is one great value of looking at his photographs, and it is one thing he had in common with the Surrealists. Like them, he had no truck with universals, whether about Paris, or beautiful parks, or daily experience. Atget's photographs are particular records of specific things. They are edgy, discomforting, full of his own point of view.

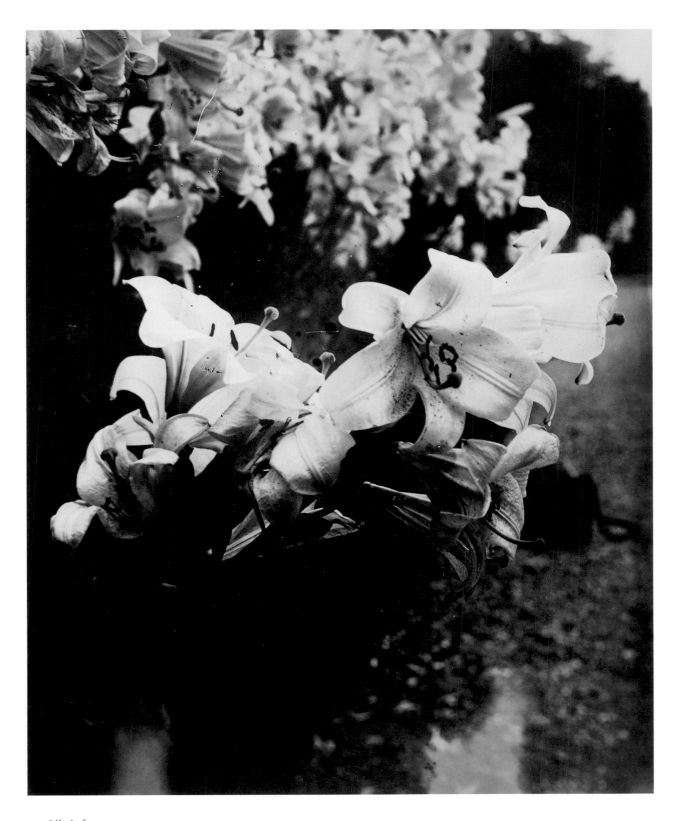

115. *Lily*, before 1900 or 1915–19
Gelatin silver chloride print. Atget negative number 794 (Landscape-Documents / Views and Plants
or Landscape-Documents / Mixed Documents)
Inscribed (by Abbott) on mount verso: *Lys*
Purchased with the Lola Downin Peck Fund, the Alice Newton Osborn Fund, other Museum funds,
and with the partial gift of Eric W. Strom, 2004-110-11

Notes

1. Berenice Abbott, "Eugène Atget," *Creative Art*, vol. 5, no. 3 (September 1929), p. 651.

2. Julien Levy to Mina Loy, July 31, 1930. Julien Levy Archive, Newtown, Connecticut.

3. The most thorough accounts of Atget's photography are John Szarkowski and Maria Morris Hambourg, *The Work of Atget*, 4 vols. (New York: The Museum of Modern Art, 1981–85); and Molly Nesbit, *Atget's Seven Albums* (New Haven: Yale University Press, 1992). See also Jean LeRoy, *Atget: magicien du vieux Paris en son époque*, 2d ed. (Paris: P. J. Balbo, 1992). For a survey of Atget's influence on other photographers, see Jean Claude Lemagny et al., *Atget, le pionnier* (Paris: Marval, 2000).

4. The story of Abbott's acquisition of the contents of Atget's workroom is told most thoroughly by Maria Morris Hambourg, "Atget, Precursor of Modern Documentary Photography," in *Observations: Essays on Documentary Photography*, ed. David Featherstone (Carmel, Calif.: The Friends of Photography, 1984), pp. 25–39. Bonnie Yochelson also recounts the tale in *Berenice Abbott: Changing New York* (New York: The New Press / The Museum of the City of New York, 1997), pp. 11–15.

5. Nesbit, *Atget's Seven Albums*, Appendix 2, pp. 260–70.

6. Berenice Abbott, "Eugène Atget," *The Complete Photographer*, no. 6 (1941), p. 337.

7. For example, the Princeton University Art Museum recently acquired 88 Atget photographs (54 printed by Atget and 34 by Abbott) and the cover to one of Atget's paper workroom albums, *Tuileries et Trianon*. Levy sold some of the works in this group in the 1960s or 70s. My thanks to Professor Peter Bunnell for sharing this information with me.

8. John Szarkowski, *Looking at Photographs: 100 Pictures from the Collection of the Museum of Modern Art* (New York: The Museum of Modern Art, 1973), p. 10.

9. Szarkowski discusses Atget in many of his publications. See particularly "Atget and the Art of Photography," in Szarkowski and Hambourg, *The Work of Atget*, vol. 1, pp. 11–26; and *Atget* (New York: The Museum of Modern Art / Callaway, 2000). It is worth noting that Szarkowski's characterization of Atget's larger subject—France, explored and expanded with each new photograph—mirrors his formalist model of the history of photography, which describes that history as internal unto itself. Photography as a whole is furthered chiefly through photographers' production and experience of photographs, with subject matter and history remaining largely incidental. See Szarkowski, *The Photographer's Eye* (New York: The Museum of Modern Art, 1966).

10. Molly Nesbit has chronicled these buyers and the ways in which they used the pictures. The present essay follows her definitive book, *Atget's Seven Albums*, and relies heavily, like all Atget publications, on the historical research conducted separately by her and Maria Morris Hambourg.

11. Two other books about individual collections of Atget photographs, very different from one another, are Josiane Sartre, *Atget: Paris in Detail*, trans. David Radzinowicz (Paris: Flammarion, 2002); and Susan Laxton, *Paris as Gameboard: Man Ray's Atgets* (New York: Miriam and Ira D. Wallach Art Gallery, Columbia University, 2002). Sartre catalogues the Atget holdings of a specialized library, the Bibliothèque des Arts Décoratifs in Paris, which acquired its prints directly from the photographer. Laxton examines the private collection put together by Man Ray, treating it as one of his Surrealist endeavors.

12. Atget's main series were Landscape-Documents, Picturesque Paris, Art in Old Paris, Environs, and Topography. The subsidiary series, which often derived from the main ones, were Old France, Costumes–Religious Art, Interiors, Tuileries, Saint-Cloud, Versailles, Paris Parks, and Sceaux. The series Landscape-Documents itself contained subsections for views and plants, work animals, Rouen, farm animals, and mixed documents. Also, over time Atget made three distinct groups of pictures for Picturesque Paris, which he numbered differently and are now called Parts I, II, and III.

 Atget's numbering system was charted by Barbara Michaels and Maria Morris Hambourg when they worked with the Abbott-Levy Collection at the Museum of Modern Art. The number lines are fully elaborated in Szarkowski and Hambourg, *The Work of Atget*, vol. 3, p. 181; and in Hambourg's essay for that volume, "The Structure of the Work," pp. 9–33. See also Barbara Michaels, "An Introduction to the Dating and Organization of Eugène Atget's Photographs," *The Art Bulletin*, vol. 61 (September 1979), pp. 460–68.

13. Gelatin silver chloride prints and matte albumen prints both came into common use in the 1890s, several years after Atget had learned photography and the manufacture of albumen silver prints. The single matte gelatin silver chloride print (2001-62-75) in the Museum's collection is a duplicate of fig. 37, which is a matte albumen silver print.

14. Throughout the medium's history many photographs have been designed to be looked at in books and in ordered groupings rather than discretely. See Carol Armstrong, *Scenes in a Library: Reading the Photograph in the Book, 1843–1875* (Cambridge, Mass.: MIT Press, 1998); and Alan Trachtenberg, *Reading American Photographs: Images as History, Mathew Brady to Walker Evans* (New York: Hill and Wang, 1989).

Both books have influenced my thinking about the modes in which Atget and his admirers looked at his photographs.

15. Hambourg discusses Atget's use of albums in "The Structure of the Work," in Szarkowski and Hambourg, *The Work of Atget*, vol. 3, pp. 10–11.

16. The album is fully reproduced in Molly Nesbit and Françoise Reynaud, *Eugène Atget, Intérieurs parisiens: un album du Musée Carnavalet* (Paris: Éditions Carré / Paris-Musées, 1992). See also Nesbit, *Atget's Seven Albums*, esp. pp. 116–25.

17. It is possible, though unlikely, that the Museum's fragmentary Paris parks album, with its many pages and no cover, formed the contents of *Album No. 1, Jardin des Tuileries* (fig. 16). Atget often gave albums new covers when he recycled them, so an album of photographs of Paris parks would probably be identified as such. Moreover, both albums contain a page for Art in Old Paris image number 5487, a Tuileries subject (fig. 109). The many number inscriptions remaining in the Paris parks album indicate that it originally held a consecutive run of photographs from the Art in Old Paris series, including many non-park subjects. In its final form it held prints from the series Art in Old Paris, Topography, and Tuileries, and probably also from Paris Parks and Landscape-Documents / Mixed Documents.

18. Nesbit, *Atget's Seven Albums*, pp. 119–20.

19. Maria Morris Hambourg, "A Biography of Eugène Atget," in Szarkowski and Hambourg, *The Work of Atget*, vol. 2, pp. 9–39, esp. pp. 24–27.

20. Sorel's autobiography is filled with passages describing the visitors she received and the dinners she gave at 99, avenue des Champs-Elysées. See *Cécile Sorel: An Autobiography*, trans. Philip John Stead (London: Staples Press, 1953).

21. Hambourg, "A Biography of Eugène Atget," in Szarkowski and Hambourg, *The Work of Atget*, vol. 2, p. 11.

22. The cadastral records in the Archives de Paris (files D13P 137-138, D9P 512, and D13P 137-138) indicate that 14 bis, rue Montaigne was owned by Léopold Dominique Picard between 1908 and 1913, and that a Madame de Féraudy, or de Ferrodi, rented there in 1910. Maurice de Féraudy, for his part, is listed at 11 bis, rue Pigalle; see Jules Martin, *Nos Artistes: Annuaire des théâtres et concerts, 1901–1902* (Paris: Société d'Éditions Littéraires et Artistiques / P. Ollendorff, 1901), p. 153. My thanks to Juliette Nunez of the Direction des Services d'Archives de Paris for helping me locate the information about 14 bis, rue Montaigne.

23. *Annuaire de Commerce Didot-Bottin* (Paris, 1910), p. 322.

24. Ibid, p. 158. On pages 21 and 80 of Atget's *répertoire*, he recorded Aristide "Cavalier-Col," a pipe organ manufacturer in the avenue du Main, and one Leroy, *artiste-décorateur* and student of "Cavalier Coll" (no address listed). The pipe organ manufacturer was also listed in the *Bottin*, and his name was given as Cavaillé-Coll. My thanks to Molly Nesbit for sharing this information with me from her notes on Atget's *répertoire*.

25. Nesbit views the incompleteness of Atget's photographs as fundamental to his work. She ties it to their status as documents, utilitarian pictures designed to serve the completion of something else. See Nesbit, *Atget's Seven Albums*, pp. 14–18, 28–35, passim.

26. The Bièvre was a small river polluted from centuries of industrial use; it was finally covered over in the 1890s. Atget's surprisingly bucolic view was presumably made some time before that. See ibid., pp. 71–73, 193.

27. *Dictionnaire de biographie française*, vol. 3 (Paris: Letouzey et Ané, 1975), pp. 1016–17. See also Paul Géraldy, *Maurice de Féraudy*, Les Célébrités dramatiques et lyriques de la scène française (Paris: R. Chiberre, 1921).

28. Berthe de Féraudy, who advertised her sculpture in the *Bottin* under her real name, nonetheless always exhibited her work under the name Berthe Ferraudy. She was born in Paris, April 15, 1878, and was a student of the sculptors Max Blondat and Moreau-Vauthier. She exhibited regularly at the Salon des Artistes Français between 1897 and 1935, and also exhibited in the Salon d'Automne of 1906. See Edouard Joseph, *Dictionnaire biographique des artistes contemporains 1910–1930* (Paris: Art & èdition, 1930–34), p. 26.

My thanks to Laure de Margerie, sculpture researcher at the Musée d'Orsay in Paris, for sharing the museum's records about Berthe Ferraudy / de Féraudy with me, and for her great help in my efforts to establish a link between Berthe de Féraudy and Maurice de Féraudy.

29. Sorel, *Autobiography*, pp. 135–41, 247–57.

30. Szarkowski (*Atget*, p. 84) observes that perhaps Monsieur B. and Monsieur C. were two friends who lived together. He rejects the idea that Atget constructed a social critique in his interiors album, and surmises that Atget made the series because he was fascinated by the photographic possibilities of interiors. See *Atget*, pp. 80–84; and Szarkowski and Hambourg, *The Work of Atget*, vol. 4, pp. 172–80.

31. Nesbit, *Atget's Seven Albums*, pp. 116–25.

32. When Atget arranged the public interiors album for sale to his library and museum clients, he designed it for institutions he knew and valued as a collective space for historical dialogue. In addition to the many photographs he sold to them, in 1911 and 1912 he gave his collections of socialist newspapers and anti-military publications to the Bibliothèque Historique de la Ville de Paris, and in 1917 he sold to the Bibliothèque Nationale his scrapbooks tracing the Dreyfus Affair, the framing of a Jewish soldier for treason, an event that rocked French society in the 1890s. See ibid., pp. 113–14, 194.

33. Nesbit discusses the albums in depth and reproduces them all. See ibid., pp. 116–211, 317–428.

34. My thanks to Dean Walker for sharing his ideas on the dating of this work.

35. Atget photographed a number of the languishing river gods around the pools that year; he mistakenly inscribed this one *Versailles (Bassin du Nord)*.

36. The sculpture group, executed by Jean-Baptiste Tuby between 1677 and 1683, celebrates France's military victories

over Spain and the Holy Roman Empire in the Thirty Years' War. The foreground figure in Atget's view is an allegory of the Holy Roman Empire.

37. Berenice Abbott, *The World of Atget* (New York: Horizon Press, 1964), p. ix. Actually, Atget had young European admirers, too, among them Florent Fels, editor of *L'Art vivant*, who published several of his photographs and vied with Abbott to buy the contents of Atget's workroom from his executor, André Calmettes. See Nesbit, *Atget's Seven Albums*, p. 214 n. 12; and Hambourg, "Atget, Precursor of Modern Documentary Photography," passim.

38. For Abbott's recollection of the sitting, see *The World of Atget*, p. ix.

39. Paul Hill and Thomas Cooper, "Interview with Man Ray," in *Dialogue with Photography* (New York: Farrar, Straus, and Giroux, 1979), p. 24.

40. For discussion of Man Ray's photography, see Laxton, *Paris as Gameboard*, pp. 2–3; Jane Livingston, "Man Ray and Surrealist Photography," in Rosalind Krauss and Jane Livingston, *L'Amour fou: Photography and Surrealism* (Washington, D.C.: The Corcoran Gallery of Art; New York: Abbeville, 1985), pp. 115–47; Sandra S. Phillips, "Themes and Variations: Man Ray's Photography in the Twenties and Thirties," in Merry Foresta et al., *Perpetual Motif: The Art of Man Ray* (Washington, D.C.: National Museum of American Art, Smithsonian Institution; New York: Abbeville, 1988), pp. 175–231; Manfred Heiting, ed., *Man Ray, 1890–1976* (Cologne: Taschen, 2000).

41. See Jennifer Mundy, ed., *Surrealism: Desire Unbound* (Princeton: Princeton University Press, 2001).

42. The now exhausted debate about whether photography is representation or noncreative record-making was particularly heated during Atget's lifetime. Nesbit (*Atget's Seven Albums*, pp. 14–18) discusses the question in relation to Atget's work and Alfred Stieglitz's 1908 poll of French artists and critics on the matter for *Camera Work*.

43. Walter Benjamin, "The Work of Art in the Age of Mechanical Reproduction," in *Illuminations: Essays and Reflections*, ed. Hannah Arendt, trans. Harry Zohn (New York: Schocken Books, 1968), p. 226.

44. Hill and Cooper, "Interview with Man Ray," p. 24.

45. Julien Levy, *Memoir of an Art Gallery* (New York: G. P. Putnam's Sons, 1977), p. 91; Hill and Cooper, "Interview with Man Ray," p. 24.

46. Hill and Cooper, "Interview with Man Ray," p. 23.

47. This is Laxton's observation. See *Paris as Gameboard*, p. 4.

48. Hill and Cooper, "Interview with Man Ray," p. 23.

49. Yochelson, *Berenice Abbott*, p. 10. For biographical information about Abbott, I rely on Yochelson and also Hank O'Neal, *Berenice Abbott, American Photographer* (New York: McGraw-Hill, 1982).

50. Abbott, *The World of Atget*, p. viii.

51. Abigail Solomon-Godeau, "Canon Fodder: Authoring Eugène Atget," in *Photography at the Dock: Essays on Photographic History, Institutions, and Practices*, Media and Society 4 (Min-neapolis: University of Minnesota Press, 1991), p. 33. Solomon-Godeau's observations about Abbott's relation to Atget's work were formative for my own statements in this essay.

52. Abbott, *The World of Atget*, p. viii.

53. Hill and Cooper, "Interview with Man Ray," p. 23; Levy, *Memoir of an Art Gallery*, p. 91; Abbott, *The World of Atget*, p. ix.

54. Ingrid Schaffner and Lisa Jacobs, *Julien Levy: Portrait of an Art Gallery* (Cambridge, Mass.: MIT Press, 1998), pp. 61–62; Levy, *Memoir of an Art Gallery*, pp. 17–18.

55. David Travis, *Photographs from the Julien Levy Collection Starting with Atget* (Chicago: The Art Institute of Chicago, 1976), p. 13.

56. Hambourg, "A Biography of Eugène Atget," in Szarkowski and Hambourg, *The Work of Atget*, vol. 2, pp. 29–31.

57. Levy informed Mina Loy of his partnership with Abbott in a letter of May 9, 1930. His insurance policy with Macomber and Company, Inc., is dated June 4, 1932. Julien Levy Archive, Newtown, Connecticut.

58. Julien Levy to H. Lee Lurie, July 25, 1964; Julien Levy to H. Lee Lurie, no date; Julien Levy Archive, Newtown, Connecticut. In 1964, after many years of little or no communication, Abbott and Levy squabbled about ownership of the Atgets in Abbott's possession, which they ultimately sold to the Museum of Modern Art as the Abbott-Levy Collection in 1969. Judging from Abbott's and Levy's published and private statements, it seems they both fibbed about the facts and dates of their partnership (most people did not know of Levy's interest in the collection until the MoMA acquisition). MoMA's archives on Abbott, Levy, and the acquisition of the Abbott-Levy Collection were not accessible to me, so my own knowledge of the dispute between them is incomplete.

59. Christopher Phillips, ed., *Photography in the Modern Era: European Documents and Critical Writings, 1913–1940* (New York: The Metropolitan Museum of Art/Aperture, 1989), pp. 27–33, 41–49.

60. Julien Levy to Mina Loy, March 12, 1930. Julien Levy Archive, Newtown, Connecticut. The Weyhe Gallery held an exhibition of Abbott's own work in conjunction with Atget's: *Six Portraits by Berenice Abbott: Andrée [sic] Gide, Jean Cocteau, Eugene [sic] Atget, James Joyce, Princess Murat, and Sophie Victor* and *Atget Photographs*, November 24 to December 6, 1930.

61. The Julien Levy Collection at the Philadelphia Museum of Art also includes Abbott's 1956 centennial portfolio of twenty Atget photographs.

62. Abbott, *The World of Atget*, p. xxix.

63. Charles Desmarais, "Julien Levy: Surrealist Author, Dealer, and Collector," *Afterimage* (January 1977), p. 6.

64. Abbott, *The World of Atget*, pp. xxviii–xxix. Among its recently acquired Atget photographs, the Princeton University Art Museum has nine unmounted prints by Abbott that she described as proof prints dating from her efforts to match the appearance of Atget's own prints (see n. 7 above).

65. Desmarais, "Julien Levy: Surrealist Author, Dealer, and Collector," p. 6.

66. This photograph forms half of a contiguous view, the only panoramic pair identified in all Atget's production (though Atget probably never mounted them together). The view of the rue des Chantres, and its mate, a view of the rue des Ursins, depict one of the last vestiges of the old Ile de la Cité, most of which was demolished and rebuilt during the Second Empire prefecture of Baron Georges-Eugène Haussmann. See Szarkowski and Hambourg, *The Work of Atget*, vol. 2, pls. 50, 51.

67. Abbott, "Eugène Atget," p. 652.

68. Abbott, *The World of Atget*, p. xxiv; Maria Morris Hambourg and Christopher Phillips, *The New Vision: Photography Between the World Wars* (New York: The Metropolitan Museum of Art, 1989), pp. 56–57.

69. Paul Cummings, Interview with Julien Levy for the Archives of American Art, Smithsonian Institution, Washington, D.C., May 30, 1975, p. 8.

70. That was Levy's estimate, years later, of how many Atgets he bought before becoming Abbott's partner. See Levy, *Memoir of an Art Gallery*, p. 93. It is important to keep in mind that Levy sold many Atget photographs over the years, but the pictures we can trace to his collection confirm the patterns I discuss here.

71. Sartre, *Paris in Detail*, p. 212.

72. Krauss discusses Surrealist photography in relation to narcissism, Sigmund Freud's writings about coincidence and the uncanny, and Jacques Lacan's development of the concept of the mirror stage; see "Corpus Delicti," in Krauss and Livingston, *L'Amour fou*, pp. 82, 85. The examples Krauss invokes — photographs by Raoul Ubac and Maurice Tabard, texts by Roger Caillois and André Breton — indicate the wide Surrealist interest in coincidence like that which Levy "found" in his photographs.

73. The story is recounted in Nesbit, *Atget's Seven Albums*, pp. 28–29.

74. It is quite possible that Levy acquired his photograph not from Atget or Abbott, but from Dignimont. In *Memoir of an Art Gallery* (pp. 122–23) Levy recounts visiting Dignimont with Lee Miller, seeking to acquire his collection. He mentions Dignimont's Atgets and then waxes erotic about other treasures Dignimont gave him that day.

75. The term is Georges Bataille's. His concept of the *informe* was the crux of his version of Surrealism, which he promoted in opposition to André Breton's dogmatic leadership of the movement. Hal Foster discusses the *informe* in relation to Surrealist photographs of the female nude; see "Violation and Unveiling in Surrealist Photography: Women as Fetish, as Shattered Object, as Phallus," in Mundy, ed., *Desire Unbound*, pp. 203–25. See also Yve-Alain Bois and Rosalind E. Krauss, *Formless: A User's Guide* (New York: Zone Books, 1997); Krauss, "Corpus Delicti," passim; and Rosalind Krauss, *The Optical Unconscious* (Cambridge, Mass.: MIT Press, 1993), passim.

76. Hambourg reports one male nude among the brothel pictures, but it has never been illustrated and I am unable to trace it. Jean LeRoy (*Atget: magicien du vieux Paris*, p. 28) illustrates another photograph of a partially nude woman on a bed, her back turned to the camera.

77. Szarkowski and Hambourg, *The Work of Atget*, vol. 3, p. 184.

78. Thomas Michael Gunther, "Man Ray and Co.: la fabrication d'un buste," *Colloque Atget*, proceedings of the conference, Collège de France, Paris, June 14–15, 1985 (Paris: Association française pour la diffusion de la photographie, 1986), p. 70. Levy also possessed fifteen of the copy nudes (including the three images Man Ray owned), all printed by Abbott from Atget's negatives; these prints, untrimmed and unmounted, are now in the Museum's collection.

79. There is no evidence that Atget ever made a copy negative of this photograph. Levy owned and sold another print of one other of the copy nudes (whether the anonymous photograph itself or a copy print by Atget is unclear). See *The Julien Levy Collection* (New York: The Witkin Gallery, 1977), p. 3.

80. Levy, *Memoir of an Art Gallery*, p. 91.

81. Ibid., p. 20.

82. Nesbit, *Atget's Seven Albums*, pp. 132–51. T. J. Clark's book *The Painting of Modern Life: Paris in the Art of Manet and His Followers* (New York: Alfred A. Knopf, 1984) remains the definitive statement on the imagery of modern life in relation to the bourgeoisie. But Clark neglects photography altogether, perhaps wishing painting to remain the ultimate medium of modernism.

83. Berenice Abbott, "It Has to Walk Alone," reprinted in Nathan Lyons, ed., *Photographers on Photography: A Critical Anthology* (Englewood Cliffs, N.J.: Prentice-Hall, 1966), p. 16.

84. Ibid., p. 15.

85. Robert Desnos, "Pygmalion et le sphinx," *Documents*, vol. 2, no. 1 (1930), pp. 33–40.

86. Krauss, "Photography in the Service of Surrealism," in Krauss and Livingston, *L'Amour fou*, p. 28.

87. I mean reading in the sense described by Alan Trachtenberg in *Reading American Photographs*, esp. pp. xiii–xvii, 164–230.

88. Nesbit, *Atget's Seven Albums*, p. 205; Szarkowski and Hambourg, *The Work of Atget*, vol. 2, pp. 176–79.

89. Quoted in Rosalind Krauss, "Photography in the Service of Surrealism," in Krauss and Livingston, *L'Amour fou*, p. 31.

90. Julien Levy, *Surrealism* (New York: Black Sun Press, 1936; reprint, Da Capo, 1995), p. 3.

91. Ibid., p. 59.

92. Levy, *Memoir of an Art Gallery*, p. 93; Cummings, "Interview with Julien Levy," p. 11; Travis, *Photographs from the Julien Levy Collection*, pp. 10–11.

93. Berenice Abbott, "It Has to Walk Alone," in Lyons, ed., *Photographers on Photography*, pp. 15–17; Berenice Abbott, "Photography at the Crossroads," in ibid., pp. 17–22.

94. Julien Levy to Mina Loy, March 12, 1930. Julien Levy Archive, Newtown, Connecticut.

95. Mac Orlan's text is translated in Phillips, ed., *Photography in the Modern Era*, p. 49.

96. It is impossible to say whether the print's blemishes appeared before or after Abbott prepared it for exhibition.

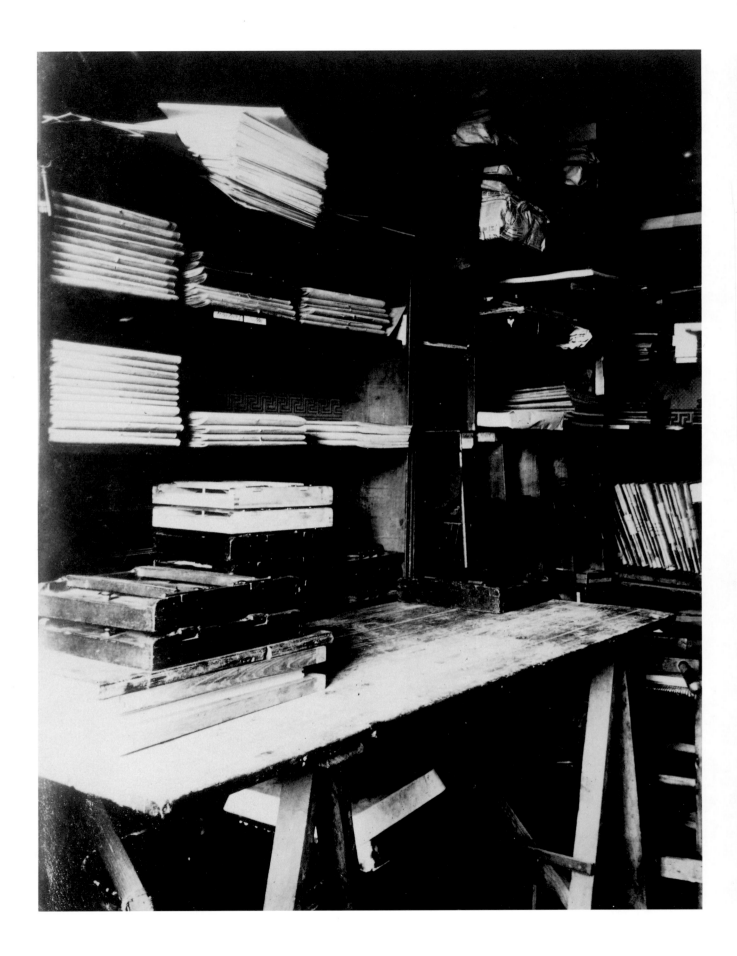

Looking at Atget's and Abbott's Prints: The Photographic Materials

Beth A. Price and Ken Sutherland

[Atget] did not veer toward excessive concern with technic [sic] *nor toward the imitation of painting but steered a straight course, making the medium speak for itself.*[1]
— Berenice Abbott, 1941

Eugène Atget's career as a photographer—from about 1890 until his death in 1927—coincided with a period in the history of photography when significant technological advances were being made in the materials and techniques of the medium. As discussed in Peter Barberie's essay for this volume, Atget made contact prints using glass-plate negatives (fig. 116) and albumen photographic papers, which allowed him to achieve sharp images and a richness of detail. However, albumen prints were recognized as being unstable and prone to fading and discoloration and were already falling out of favor in France by the end of the nineteenth century, when more stable gelatin photographic papers began to dominate the market.[2] Nevertheless, Atget continued to produce albumen prints well into the 1920s (see Barberie, pp. 12–14), though at times he used other papers such as matte albumen, gelatin, and matte gelatin, each with its own properties and distinctive appearance. Berenice Abbott—herself a photographer and one of the most skilled printers of the twentieth century—reprinted many of Atget's negatives after his death, having purchased the contents of his workroom from André Calmettes, the executor of Atget's estate.[3] Abbott experimented with a variety of photographic papers and processes to reproduce the clarity and detail found in Atget's work. The materials used by Atget and Abbott—their photographic papers, as well as the toning compounds and coatings used to further adjust the appearance of their printed images—are the subject of this essay. A selection of twenty-two of the Museum's Atget prints and fourteen of its prints produced by Abbott from his negatives were examined; several of these prints will be discussed here to illustrate the range of materials used by the two photographers.

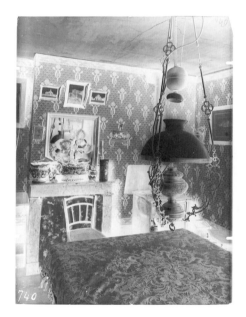

116. Glass-plate negative for *Interior of a Working-Class Man, rue de Romainville*, 1910 (fig. 41)
Atget negative number 740 (Interiors)
Purchased with the Lola Downin Peck Fund, the Alice Newton Osborn Fund, other Museum funds, and with the partial gift of Eric W. Strom, 2004-110-13

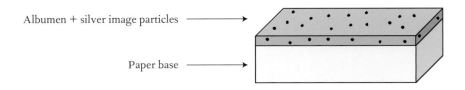

Albumen + silver image particles ⟶

Paper base ⟶

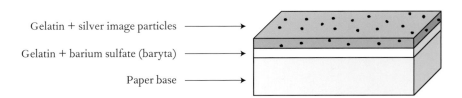

Gelatin + silver image particles ⟶

Gelatin + barium sulfate (baryta) ⟶

Paper base ⟶

117. General structures of albumen (*top*) and gelatin (*bottom*) photographic papers

The Photographic Papers

Albumen and gelatin photographic papers such as those used by Atget and Abbott are composed of several layers, as illustrated in figure 117.[4] Albumen paper has a two-layer structure consisting of an upper layer of albumen binder made from the whites of eggs and a paper base that acts as a support. The albumen binder contains the light-sensitive silver salt from which the image is formed. Gelatin paper, made using gelatin derived from animal collagen, generally has a three-layer structure. The gelatin emulsion layer,[5] which incorporates the silver salt, rests on a primed paper base. The priming layer, called the baryta layer, is made from a suspension of barium sulfate ($BaSO_4$) in gelatin and provides a smooth and reflective substrate for the image layer that enhances contrast in the print. Matte albumen and matte gelatin papers are variations of the types described above in which starch is incorporated into the binder.

Atget produced his photographs exclusively with the "printing-out" process — that is, the process by which images appeared spontaneously when exposed to sunlight, without the use of developing chemicals. In this technique the photographic paper, either albumen or gelatin, was placed in direct contact with a glass-plate negative in a printing frame and exposed to sunlight until the desired degree of darkening had occurred.[6] After exposure, the print was rinsed, fixed, and washed to eliminate any excess silver salt. According to Abbott, with this process Atget could make "as many prints as he had frames for since the paper was the slow 'printing out' type."[7] That is, the gradual appearance of the image allowed him to work with several negatives simultaneously. The printing-out process, which was the predominant printing method in the nineteenth century, declined in favor of the more rapid "developing-out" process in the early twentieth century. Developing-out papers, which were made using gelatin but not albumen, required exposure to light followed by treatment of the exposed photographic paper in a developing solution to bring out the latent image. In contrast to Atget's working method, Abbott used the developing-out process for the prints that she made from his negatives.[8]

118. Photomicrograph detail of *Interior, rue du Montparnasse* (2001-62-98, not illustrated), showing a network of fine cracks in the albumen binder (image width ¼ inch [6 mm])

The different types of papers that Atget and Abbott used sometimes can be classified by careful visual examination. Typically, albumen papers are thin. If left unsupported or unmounted, albumen prints tend to curl inward toward the image side of the paper. They usually show some degree of gloss, often have yellow highlights, and have an image hue that typically ranges from brick red to purple-black. Upon microscopic examination, they may exhibit a distinctive network of fine surface cracks, or craquelure (fig. 118), and because of the absence of a priming layer, the fibers in the paper base are discernible through the albumen binder. Gelatin prints, in contrast, do not exhibit the fine craquelure of albumen prints and generally have a smooth surface due to the baryta layer, which usually obscures the texture of the paper base. The highlights typically remain white, while the image hue may be similar to that of albumen prints or a neutral gray-black. Left unmounted, gelatin prints may curl inward or outward depending on the relative humidity.

The exact types of photographic papers used cannot always be distinguished easily, however, especially if a variety of materials and techniques were employed.[9] Such is the case with Atget, who, despite his consistent employment of glass-plate negatives and the printing-out process, sometimes used papers other than albumen. It is also true of Abbott, who experimented with a variety of papers to approximate Atget's prints. Chemical analysis by analytical methods is therefore valuable in providing definitive identification of the photographic materials, including the binders, as well as other components in the photograph such as toning compounds and surface coatings.[10] For the study of the Museum's Atget prints and Abbott prints from Atget's negatives, the methods applied to identify the photographic materials were Fourier transform infrared microspectroscopy (MFTIR), gas chromatography mass spectrometry (GCMS), polarized light microscopy (PLM), scanning electron microscopy (SEM), and energy dispersive spectroscopy (EDS).[11]

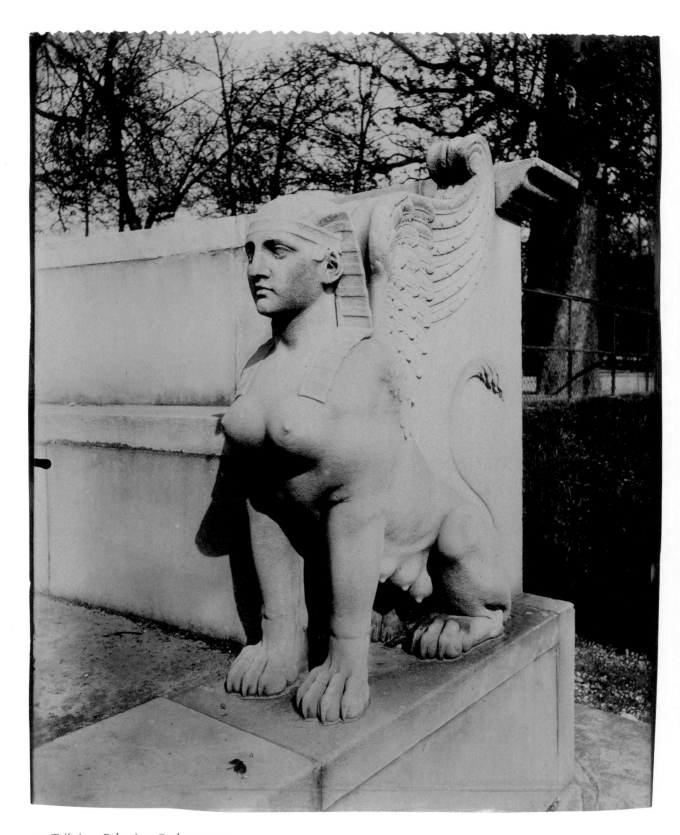

119. *Tuileries—Robespierre Garden*, 1911–12
Albumen silver print. Atget negative number 240 (Tuileries)
Inscribed on verso: *Tuileries—Jardin de / Robespierre*
The Lynne and Harold Honickman Gift of the Julien Levy Collection, 2001-62-212

120. *Versailles*, 1904
Gelatin silver print. Atget negative number 6480
(Environs)
Inscribed on verso: *Versailles*
The Lynne and Harold Honickman Gift of the
Julien Levy Collection, 2001-62-287

The Binders

Based on visual examinations of the Museum's collection, approximately two
hundred (or three-quarters) of the Atget prints were classified as albumen and
the remainder as gelatin; all of the Abbott prints from Atget's negatives were
classified as gelatin. Technical analyses were carried out on thirty-six of the
prints. For those with pure albumen and gelatin binders, the analytical results
corroborated the initial classifications. *Tuileries—Robespierre Garden* (fig. 119)
and *Versailles* (fig. 120) are examples, respectively, of an albumen print and a
gelatin print by Atget, as confirmed by FTIR analysis. The binders in both pho-
tographs are composed primarily of proteins and thus exhibit similar features in
their infrared spectra (fig. 121), including prominent peaks (absorption bands) at
3297, 3072, 1650, and 1535 wavenumbers (cm^{-1}).[12] Although chemically similar,
the component proteins of albumen and gelatin have distinct secondary struc-
tures,[13] meaning that subtle differences are visible in specific regions of their
spectra upon close examination. Figure 122 shows an expanded region where
the positions, shapes, and intensities of the bands for the two binders are differ-
ent (1500–1240 cm^{-1}).[14]

The binders in *Tuileries—Robespierre Garden* and *Versailles* were studied
further using the complementary method GCMS. With this technique, micro-
scopic samples of the binder protein were broken down chemically into their
component amino acids, which were then separated and measured. The relative
proportions of detected amino acids indicated which type of protein—albumen
or gelatin—was present in the binder. Figure 123 shows the GCMS data ob-
tained for binder samples from the two prints, with peaks in the total ion chro-
matograms (TIC) representing individual amino acids. The binders are clearly

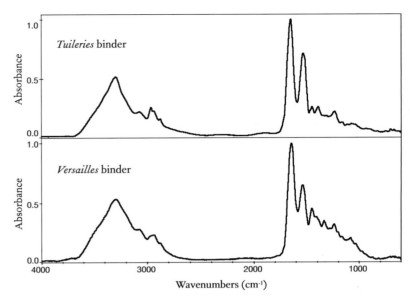

121. Infrared spectra of the binder from *Tuileries—Robespierre Garden* (fig. 119), an albumen print, and *Versailles* (fig. 120), a gelatin print. Both spectra feature absorption bands characteristic for proteinaceous materials.

122. Expanded region of the spectra in figure 121. The absorption bands in the 1500–1240 cm⁻¹ region allow differentiation of albumen from gelatin.

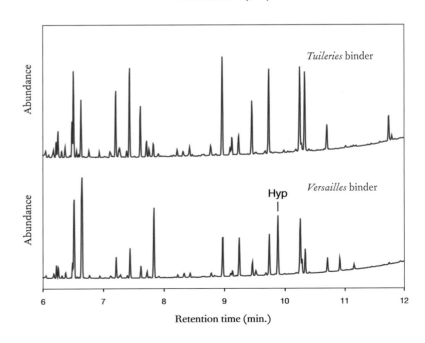

123. Total ion chromatograms (TIC) from GCMS analysis of the binder from *Tuileries Robespierre Garden* (fig. 119) and *Versailles* (fig. 120). The peak corresponding to the amino acid hydroxyproline (Hyp) is labeled for *Versailles*; this compound is characteristic of collagen-based proteins such as gelatin.

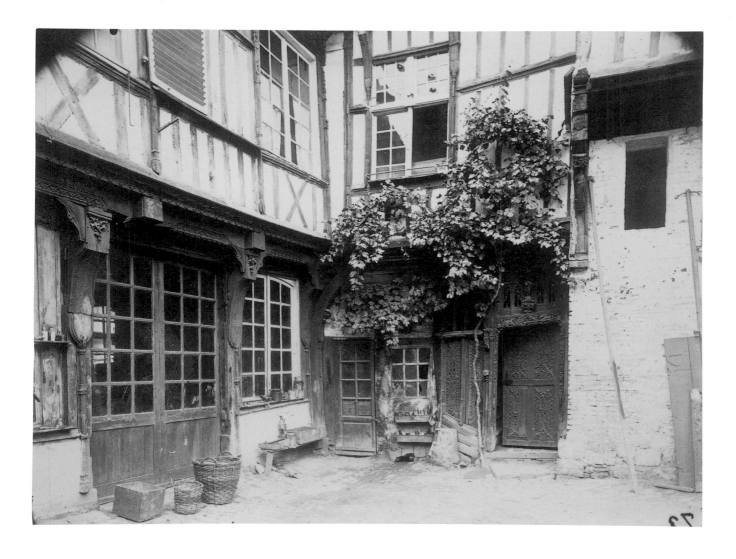

124. *Old House in Abbeville*, before 1900
Matte albumen silver print. Atget negative number 72 (Landscape-Documents / Views, Plants)
Inscribed (by Abbott) on mount verso: *Vielle maison à Abbeville*
Gift of Carl Zigrosser, 1953-64-32

identified from their amino acid compositions. In particular, the presence of a significant level of the amino acid hydroxyproline (Hyp) — as seen in the TIC for *Versailles* — is indicative of a collagen-based protein such as gelatin; this amino acid is absent from the albumen binder of *Tuileries — Robespierre Garden*.[15]

In addition to pure albumen and gelatin, some of the binders in Atget's prints were formulated with starch, giving them a matte finish. Two examples are *Old House in Abbeville* (fig. 124), a matte albumen print, and *Interior of Monsieur F., Merchant, rue Montaigne — The Kitchen* (2001-62-75, not illustrated),[16] a matte gelatin print. Scanning electron micrographs of binder samples from these prints are shown in figures 125A and 125B, respectively, along with a micrograph of a pure albumen binder sample from *Tuileries — Figure* (2001-62-210, not illustrated) for comparison (fig. 125C). The starch granules, clearly visible in the two matte binders as regularly sized polygonal particles (c. 5 μm diameter), influence the degree of matteness of these prints by scattering the light at the surface. The higher concentration of starch granules in the *Old House in Abbeville* binder (fig. 125A) thus correlates with its more highly matte, velvet-like finish, whereas the sparsely dispersed granules of the *Interior of Monsieur F.* binder (fig. 125B) effect a semi-glossy or satin-like surface. The albumen binder of *Tuileries — Figure*

<center>(A) (B) (C)</center>

125. Scanning electron micrographs of the binders from (A) *Old House in Abbeville* (fig. 124), (B) *Interior of Monsieur F.* (2001-62-75, not illustrated), and (C) *Tuileries—Figure* (2001-62-210, not illustrated), showing the starch granules in the matte binders (A) and (B)

contains no starch and thus produces a smooth, glossy surface. The presence of starch in the binders of *Old House in Abbeville* and *Interior of Monsieur F.* is also demonstrated by prominent absorption bands in their infrared spectra (3350 and 1152–1024 cm^{-1});[17] figure 126 shows a spectrum for the *Old House in Abbeville* binder, which also includes characteristic bands for albumen.

Various types of starch were used in nineteenth-century matte papers, including rice and arrowroot (the latter term has been used to describe certain types of matte paper from this period).[18] To determine the specific type of starch used in *Old House in Abbeville* and *Interior of Monsieur F.*, the binder samples were examined further with polarized light microscopy (PLM). Photomicrographs of a dispersion of the binder from *Interior of Monsieur F.* taken in polarized and normal light are shown in figure 127. The starch in both prints was identified as rice starch, based on the size and morphological characteristics of the granules and their behavior in polarized light.[19] Arrowroot starch was not present in the

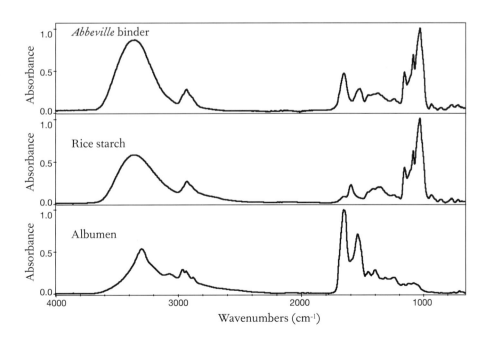

126. Infrared spectrum of the binder from *Old House in Abbeville* (fig. 124) with reference spectra for rice starch and albumen

(A) (B)

127. Photomicrographs of the binder from *Interior of Monsieur F.* (2001-62-75) taken in (A) normal and (B) polarized light, showing the presence of granules with the characteristics of rice starch

binders of the Atget photographs examined in this study.[20] Although matte papers were experiencing a revival in the early part of the twentieth century, and their properties clearly interested Atget, he continued to produce the majority of his prints using more glossy papers, primarily albumen.

The Museum's Abbott prints made from Atget negatives were produced on gelatin silver papers. However, Abbott also experimented with matte papers, as illustrated by *Brothel, Versailles, Petite Place, March 1921* (see fig. 100). This is one of a number of prints she made using a paper with a gelatin and starch binder. Although *Brothel* is a type of gelatin print, its appearance more closely approximates Atget's matte albumen prints rather than his smoother matte gelatin prints. It is therefore a good example of Abbott's efforts to emulate the visual effects of Atget's prints while employing slightly different photographic materials.

The Toning Compounds

Toning compounds have long been employed to modify the appearance of photographs. In the gold toning process, commonly used in the nineteenth century, a photographic print was treated with a solution of gold chloride (AuCl), resulting in the partial replacement of the silver image particles in the binder layer with gold. The resultant gold-silver particles impart a different hue to the image and are more resistant to the destructive process of oxidation.[21] Gold toning of printed-out prints tended to change the image hue from brick red to purple-black; it was also used as a means of improving the stability of albumen prints, which are notoriously unstable and often fade and yellow over time. Consequently, almost all albumen prints from the nineteenth century were toned in this way.[22] On Atget's use of gold toning, Abbott recalled in 1964, "His prints were superb. I believe gold [toned] chloride paper was the type used; it had, in my opinion, a tonal range and quality superior to those obtainable today."[23] Atget's use of gold toning for his albumen prints in the Museum's collection was confirmed by EDS.[24] An EDS spectrum acquired from the binder of Atget's *Versailles* (fig. 128), shown in figure 129A, includes a significant peak for gold (Au).[25] The photograph is well preserved, exhibiting a deep purplish hue and

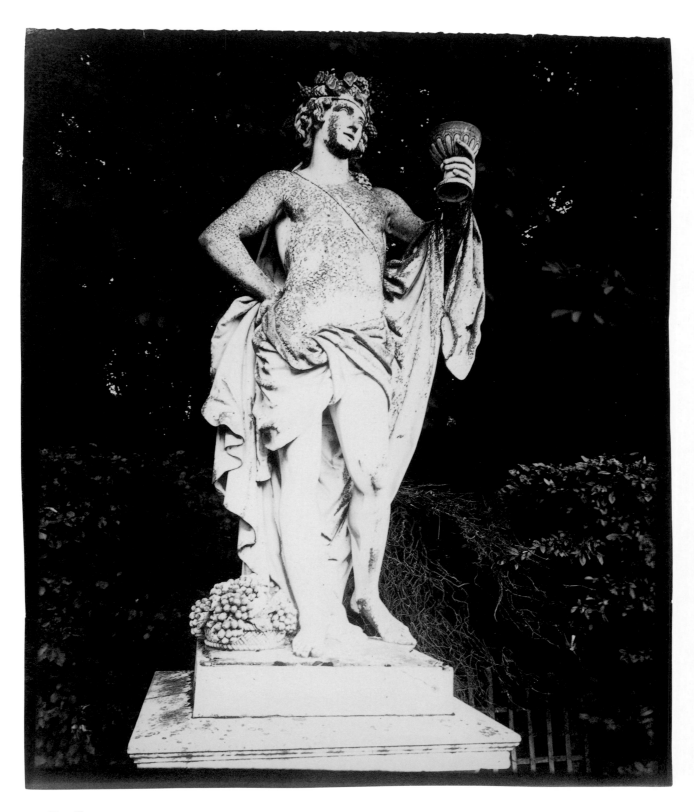

128. *Versailles*, 1923–24
Albumen silver print. Atget negative number 1216 (Versailles)
Inscribed on verso: *Versailles*
The Lynne and Harold Honickman Gift of the Julien Levy Collection, 2001-62-276

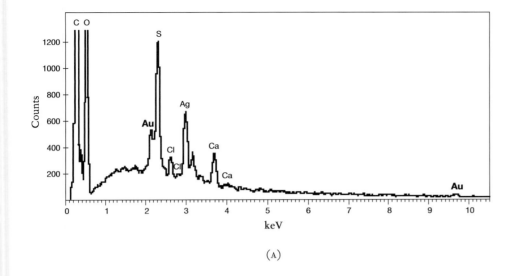

(A)

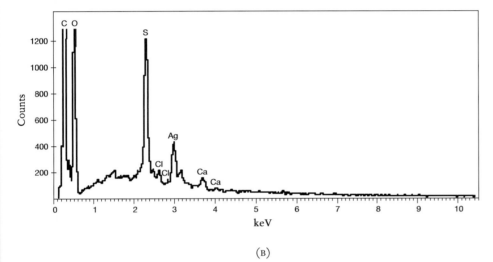

(B)

129. Energy dispersive spectra from the binders of (A) *Versailles* (fig. 128) and (B) *Tuileries Garden, Lion and Crocodile by Cain* (fig. 130). A peak for gold (Au) is visible in the spectrum for *Versailles*; gold is not evident in the spectrum for *Tuileries*.

wide tonal range consistent with the effects of gold toning. In contrast, *Tuileries Garden, Lion and Crocodile by Cain* (fig. 130), another of Atget's albumen prints, has a distinct brown hue that suggests little or no toning, as confirmed by EDS data (fig. 129B), which did not show a detectable level of gold.

In addition to gold toning of albumen prints, an extensive range of other compounds and processes was used to achieve variations in both the color and quality of photographic images. Julien Levy, the art dealer whose collection is the source of many of the Atget photographs and Abbott prints in the Museum's collection, makes reference to experiments that he and Abbott conducted with gold and platinum toning of various papers in an attempt to reproduce the tonal qualities of Atget's prints: "We experimented with every paper we could find . . . hand-coated, platinum, double hand-coated. We ended up, finally, with a semi-gold paper made by Gevaert."[26] Although platinum- and gold-toned Abbott prints were not found in the current study, selenium toning was detected in a number of cases, including a group of three prints that Abbott produced from a single Atget negative, *Place du Tertre* (fig. 131 and 2001-62-352, 353 [not illustrated]). These prints exhibit a brown to cool-purple quality characteristic

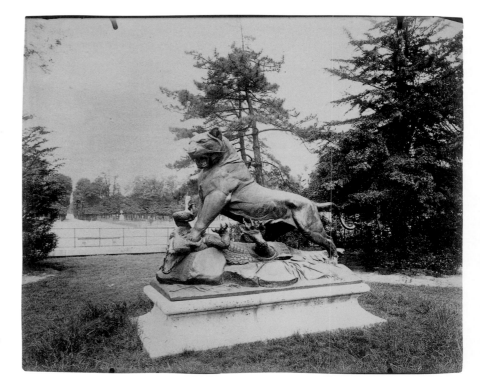

130. *Tuileries Garden*, Lion and Crocodile by
Cain, 1903
Albumen silver print. Atget negative number
4706 (Art in Old Paris)
Inscribed on verso: *Jardin des Tuileries— Lion
/ et Crocodile par Cain / 1903 (1e arr)*
The Lynne and Harold Honickman Gift of the
Julien Levy Collection, 2001-62-125

131. *Place du Tertre*, 1922
Printed by Berenice Abbott, c. 1930
Gelatin silver print. Atget negative number
6307 (Art in Old Paris)
Inscribed (by Abbott) on mount verso: *Place
du Tertre*
The Lynne and Harold Honickman Gift of
the Julien Levy Collection, 2001-62-354

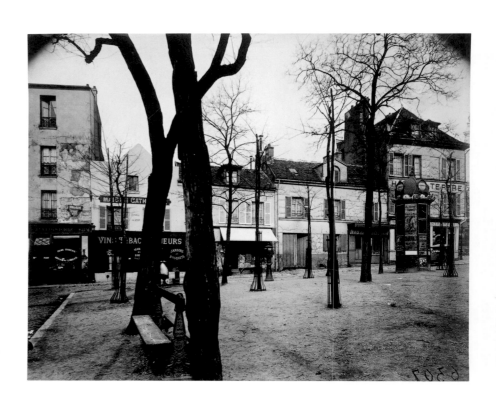

of selenium-toned gelatin developed-out prints. The selenium in *Place du Tertre* is evident in the EDS spectrum in figure 132, which also shows peaks for barium derived from the baryta layer of the gelatin print.

The Surface Coatings

Photographers applied coating materials to their prints as an alternative means to adjust surface quality and provide protection from atmospheric degradation. Such materials as waxes, resins, and gums were often applied as coatings to nineteenth-century prints to enhance the image or modify the surface gloss.[27] Whether or not Atget used coatings on his photographs is an intriguing and complex question. Although he is known to have varnished his glass negatives[28] and his application of coatings to his prints has been suggested in the literature,[29] no evidence was found for coatings on the Museum's Atget photographs examined in this study. The only organic materials identified on the surfaces of the prints corresponded to the binder materials: albumen, gelatin, and starch. Other materials that may represent coatings, such as waxes or resins, were not detected, although the use of coating materials identical to the binder—gelatin or albumen—cannot be ruled out on the basis of chemical analysis. Moreover, most of the Museum's Atget prints are on albumen paper and are not mounted to a rigid secondary support; thus, it would have been difficult to coat these thin, fragile prints. However, some of the prints examined did exhibit surface features that could be mistaken for evidence of coatings, such as lacunae (small voids) and tidelines (lines of built-up organic material at the edges), as shown in a detail of *Tuileries Garden, Lion and Crocodile by Cain* (fig. 133). FTIR analysis of the surface materials in these prints detected only albumen, and such features appear to be artifacts of the irregular application and distribution of the photographic binder rather than of intentional coatings.[30] Generally speaking, the differences observed in the appearance of Atget's prints in this study likely result from such factors as uneven distribution and discoloration of the binder, different types and quantities of toning compounds, or deterioration due to residues of processing chemicals,[31] rather than from the application of additional surface materials.[32]

133. Photomicrograph detail of *Tuileries Garden, Lion and Crocodile by Cain* (fig. 130), showing a "tideline" where the albumen binder has accumulated at the edge of the paper and is darkened (image width ⅜ inch [9 mm])

(A)

(B)

134. Details of Abbott's print of *Place du Tertre* (fig. 131) taken in ultraviolet light, showing the presence of a yellow fluorescent coating, which does not quite extend to the top edge of the photograph where indicated by an arrow in detail (A); the uneven application of the coating is visible in (B).

Abbott's experimentation with photographic materials included the use of coatings on gelatin prints, as illustrated by her *Place du Tertre* (see fig. 131). An unevenly applied, yellowed coating is apparent on this print, and it is more evident under ultraviolet (UV) illumination because of the pronounced fluorescence of the aged coating. Two details of the photograph in UV light show an area where the coating does not quite extend to the edge of the print (fig. 134A), and an area where the coating is unevenly applied (fig. 134B). Combined FTIR and GCMS analysis indicated that the coating is dammar resin, a tree resin commonly used for a variety of varnish applications.[33] The infrared data are shown in figure 135 along with a reference spectrum for dammar resin.[34] As mentioned, this photograph is one of a group of three prints in the Museum's collection produced by Abbott from a single Atget negative. Abbott's use of a dammar coating to saturate the surface of one of the prints provides particular insight into her experimental approach in manipulating Atget's images in her attempts to faithfully reproduce the detail and contrast found in his own prints.

Final Thoughts

Throughout his long career, Eugène Atget used the traditional printing-out method, primarily with albumen papers, despite technological advances that provided for more stable photographic materials and more rapid printing methods. Berenice Abbott understood Atget's faithfulness to his technique: "The technical means he used were perfect for him. He found the method best suited for his purpose and stayed with it. . . . He knew that one of the intrinsic properties of photographic excellence is clear-cut sharp detail. This meant a large negative and a contact print, regardless of whether they were considered old-fashioned or not."[35]

Abbott, on the other hand, had to be more experimental in her approach when printing from Atget's negatives since the outmoded materials favored by

135. Infrared spectrum of the coating from Abbott's print of *Place du Tertre* (fig. 131) with a reference spectrum for dammar resin

Atget were no longer readily available to her. In 1941 she summarized the situation: "His negatives seem admirably exposed for the gold chloride paper of his time. For modern printing papers, with their woeful lack of latitude, the plates are hopelessly contrasty."[36] Abbott knew that her difficulties stemmed from the tonal range of Atget's negatives, which were ideally suited to his albumen printing-out papers but not to her gelatin developing-out papers. She expressed frustration at times when the newer gelatin developing-out papers could not be coaxed into providing the qualities that Atget achieved with his "old-fashioned" glass plates and albumen photographs. Despite these challenges, Abbott continued to print from Atget's negatives over several decades to reproduce and promote his work.

Through our technical studies of the Museum's remarkable collection of Atget's photographs and Abbott's prints from his negatives, we now can better appreciate why their works have different appearances. This substantial collection of photographs, including multiple prints from individual negatives, provides a rare opportunity to view these works with an appreciation for the subtle effects of the photographic materials and printing methods that Atget and Abbott so deliberately selected.

Notes

1. Berenice Abbott, "Eugène Atget," *The Complete Photographer*, vol. 1, no. 6 (1941), p. 337.

2. See James M. Reilly, *The Albumen and Salted Paper Book: The History and Practice of Photographic Printing, 1840–1895* (Rochester, N.Y.: Light Impressions, 1980), pp. 104–5.

3. James Borcoman, *Eugène Atget, 1857–1927* (Ottawa: National Gallery of Canada, 1984), p. 104.

4. Detailed descriptions of the production of albumen and gelatin papers are found in Paul N. Hasluck, ed., *The Book of Photography: Practical, Theoretic and Applied* (London: Cassell and Co., 1905), pp. 164–85.

5. The term *binder* is used in this essay for both albumen and gelatin. The more specific term *emulsion* describes gelatin binders, in which a light-sensitive silver salt was added directly to the gelatin prior to its application to the photographic paper. Albumen binders differ from gelatin binders in that they were prepared by mixing albumen with a chloride salt, such as sodium chloride (NaCl), before application to the paper support. Once dry, the albumen layer was sensitized by treatment with a solution of silver nitrate ($AgNO_3$) to form the light-sensitive silver salt (AgCl). For more detailed descriptions of these processes, see ibid., pp. 167–72, 175–76.

6. Abbott reported that Atget's glass plates were manufactured by the Lumière Brothers: "On this point it is possible to be specific, because the boxes have been preserved." Abbott, "Eugène Atget," p. 338. She later commented: "Plates are virtually impossible to find today, but they are superior; they lie flat in their holders, are a better support for the emulsion, and give finer resolution and grain. But they are also much heavier and can break." Abbott, *The World of Atget* (New York: Horizon Press, 1964), pp. xxvii–xxviii. The Julien Levy Collection at the Philadelphia Museum of Art includes four of Atget's glass-plate negatives: nos. 732, 740, and 741 (Interiors); and 6480 (Art in Old Paris); accession nos. 2004-110-14, 2004-110-13, 2001-62-43, and 2001-62-44, respectively. No. 732 entered the Museum collection broken. The Museum also has prints made by Atget from two of the negatives (see figs. 41, 67). The glass negatives were not examined as part of the current study.

7. Abbott, *The World of Atget*, p. xxviii.

8. See "A Note on Atget's Prints," in John Szarkowski and Maria Morris Hambourg, *The Work of Atget*, vol. 4, *Modern Times* (New York: The Museum of Modern Art, 1985), p. 179.

9. Borcoman, *Eugène Atget*, p. 105; Anne Cartier-Bresson, "Techniques d'analyse appliquées aux photographies d'Eugène Atget conservées dans les collections de la ville de Paris," in *ICOM Committee for Conservation, 8th Triennial Meeting, Sydney, Australia, 6–11 September, 1987* (Los Angeles: Getty Conservation Institute, 1987), p. 654.

10. Microscopic samples were obtained for analysis from the irregular edges of photographs, or from small tears or areas of losses, using a surgical scalpel under a binocular microscope. Sampling was carried out in consultation among the Museum's scientists, conservators, and curators.

11. MFTIR, GCMS, SEM, and EDS analyses were performed in the Scientific Research and Analysis Laboratory of the Philadelphia Museum of Art. For MFTIR analysis, samples were mounted on a Spectra-Tech diamond window with a Spectra-Tech roller tool and run on a Nicolet Continuum microscope (MCT/A detector) attached to a Nexus 670 spectrometer (KBr beamsplitter) purged with dry air. The data were collected in transmission mode at 4 cm^{-1} resolution, 3.1649 mirror velocity, 200 scans per spectrum, from 4000 to 625 wavenumbers (cm^{-1}), and processed with Mertz phase correction and Happ-Genzel apodization, using Nicolet Omnic 6.0a software.

 For GCMS analysis, samples were prepared by adding 6N HCl and heating at 100°C overnight to hydrolyze proteins, dried under N_2, and the residue reacted with silylating reagent (Pierce: MTBSTFA containing 1% TBDMCS in pyridine), heating at 60°C for ½ hour and then at 100°C for 4 hours, to convert amino and fatty acids to their tert-butyl-dimethylsilyl derivatives. After cooling, 1 μL of the sample solution was injected into the GC. An Agilent 6890N GC was used with a HP5MS column (30 m, 0.25 mm i.d., 0.25 μm film), interfaced to a 5973N MS, with the following conditions: GC injector 260°C; MS interface 300°C; oven programmed from 80°C, with a 1 minute hold, increased 20°C/min to 320°C, held isothermally for 7 minutes; total run time 20 minutes; injector in splitless mode, with 0.7 minute purge-on time; helium carrier gas, with a linear velocity of 45 cm/sec; MS in scan mode (m/z 50–550) with a 5 minute solvent delay; ion source at 230°C and quad at 150°C. Data were processed using Agilent Chemstation software.

 SEM imaging and EDS analyses were carried out using a JEOL 6460LV scanning electron microscope with an Oxford INCA x-sight EDS detector and INCA Energy 200 software. An accelerating voltage of 10–20 kV was used.

12. MFTIR was used to determine the major structural (functional) groups—that is, the types and arrangements of atoms in the samples. The peaks in the spectra correspond to: NH stretch (c. 3298 cm^{-1}); amide II overtone (c. 3072 cm^{-1}); CH_2

and CH₃ stretches (c. 2962–2878 cm⁻¹); and amide I, II, and III bands (c. 1649, 1536, 1236 cm⁻¹, respectively). See Nak-ho Sung, "Structure and Properties of Collagen and Gelatin in the Hydrated and Anhydrous Solid State" (S.D. diss., Massachusetts Institute of Technology, 1972), pp. 117–22. See also George Socrates, *Infrared and Raman Characteristic Group Frequencies: Tables and Charts*, 3d ed. (Chichester, UK: John Wiley & Sons, 2001), p. 334.

13. Socrates, *Infrared and Raman Characteristic Group Frequencies*, p. 333.

14. The peaks represent CH₂ and CH₃ deformations (c. 1451, 1391, 1312 cm⁻¹), COO⁻ stretch (c. 1408 cm⁻¹), and the amide III band (c. 1236 cm⁻¹). See Sung, "Structure and Properties of Collagen and Gelatin in the Hydrated and Anhydrous Solid State," p. 119.

15. GCMS analysis corroborated the identification of albumen and gelatin by FTIR. While GCMS is often necessary for definitive identification of proteins in artists' materials, early photographic binders are composed of relatively pure proteinaceous materials and frequently can be determined using FTIR alone.

16. This print is a duplicate of *Interior of Monsieur F., Merchant, rue Montaigne—The Kitchen* (fig. 37), a matte albumen silver print.

17. These bands correspond to the OH stretch (3350 cm⁻¹) and C-O-C and C-O-H stretches (1152–1024 cm⁻¹). See Andrzej Gałat, "Study of the Raman Scattering and Infrared Absorption Spectra of Branched Polysaccharides," *Acta Biochimica Polonica*, vol. 27, no. 2 (1980), p. 139.

18. Reilly, *The Albumen and Salted Paper Book*, p. 21.

19. The identification as rice starch was based on the polygonal shape of the grains; their average size of about 5 μm; the hilia (or central clefts) visible as round spots; and the centered or slightly skewed black crosses visible between crossed polars. See Scott F. Stoeffler, "Examination of Starch in Atget Photograph Emulsions," McCrone Associate Project MA41997, November 17, 2004, report on file in Scientific Research and Analysis Laboratory, Philadelphia Museum of Art.

20. Arrowroot starch has significantly larger particles (typically 30–45 μm) than rice starch (5 μm) and was ruled out on this basis (ibid., p. 2).

21. James M. Reilly, *Care and Identification of 19th-Century Photographic Prints* (Rochester N.Y.: Eastman Kodak Co., 1986), p. 23.

22. Ibid., p. 5.

23. Abbott, *The World of Atget*, p. xxvii.

24. EDS is used to determine qualitatively the elements present in a sample. The x-rays emitted from a sample during exposure to a beam of electrons of suitable energy are characteristic of the atoms in the sample, and their measurement allows its elemental composition to be determined. The data are displayed as an EDS spectrum.

25. After toning, albumen prints were fixed with a solution of sodium thiosulfate (Na₂S₂O₃) and washed to remove un-

reacted silver salts and excess fixer. The small quantities of chlorine detected by EDS suggest residues of the silver salt (silver chloride). The sulfur may derive in part from thiosulfate and from sulfur-containing amino acids in the albumen protein. The silver is from the metallic silver particles that form the photographic image in the binder. Calcium may reflect surface contamination or traces of filling and whitening compounds in the paper support (K. Eremin, personal communication to Ken Sutherland, November 4, 2004).

26. Charles Desmarais, "Julien Levy: Surrealist Author, Dealer, and Collector," *Afterimage* (January 1977), p. 6.

27. Reilly states that "surface coatings were not routinely applied to 19th-century prints" (*Care and Identification of 19th-Century Photographic Prints*, p. 30), but recent studies suggest that the use of coatings may have been more widespread. See Clara von Waldthausen, "Coatings on Nineteenth-Century Salted Paper, Albumen, and Platinum Prints," and Julie Lattin DesChamps, "Coatings on Gelatin Silver Prints: A Historical Overview," both in *Coatings on Photographs: Materials, Techniques, and Conservation*, ed. Constance McCabe (Washington, D.C.: American Institute for Conservation of Historic and Artistic Works, Photographic Materials Group, in press).

28. Abbott recalled, "The most damaging thing that Atget did was to varnish the plates and scratch numbers directly into the emulsion at the lower right-hand corner" (*World of Atget*, p. xxx). He varnished the plates, Abbott said, "with the erroneous idea that it would preserve [them]. . . . The result is that today many of the most beautiful negatives are peeling and cracking" ("Eugène Atget," p. 338). The Atget negatives in the Julien Levy Collection at the Philadelphia Museum of Art do not exhibit these features and appear to be unvarnished (see n. 6 above).

29. Cartier-Bresson, "Techniques d'analyse," p. 653.

30. Uneven distribution of the albumen binder may result from the way the paper was hung to dry after being coated with albumen. See M. Aleo, "On the Preparation of Positive Paper," *The Photographic News* (June 29, 1860), p. 101. The fact that Atget did not carefully trim his photographs is another possible reason that irregularities in the surfaces such as tidelines and gaps in the binder material—sometimes suggestive of the presence of a surface coating on initial examination—may be more common in his photographs. See Szarkowski and Hambourg, *The Work of Atget*, vol. 4, p. 175; and Abbott, *The World of Atget*, p. xxix.

31. For discussions of deterioration and image degradation in albumen and gelatin prints, see Reilly, *The Albumen and Salted Paper Book*, pp. 101–11; and Bertrand Lavédrine, *A Guide to the Preventive Conservation of Photograph Collections*, trans. Sharon Grevet (Los Angeles: Getty Conservation Institute, 2002), pp. 3–29.

32. The presence of coatings can be difficult to detect because of the variety of materials that were employed. See Waldthausen, "Coatings on Nineteenth-Century Salted Paper, Albumen,

and Platinum Prints"; and DesChamps, "Coatings on Gelatin Silver Prints: A Historical Overview." Furthermore, the detection of thin and degraded coatings can challenge the limits of analytical techniques such as those used in this study. The use of coatings by Atget and Abbott is therefore the subject of ongoing research.

33. H. W. Chatfield, *Varnish Constituents* (London: Leonard Hill, 1953), p. 189.

34. FTIR is not a definitive technique for the identification of different types of natural resin. In this case, GCMS analysis was used to confirm that the coating material on *Place du Tertre* (fig. 131) was dammar, from the detection of characteristic triterpenoid components.

35. Abbott, *The World of Atget*, p. xxvii.

36. Abbott, "Eugène Atget," p. 338.

Selected Bibliography

Abbott, Berenice. "Eugène Atget." *Creative Art*, vol. 5, no. 3 (September 1929), pp. 651–56.

———. "Eugène Atget." *The Complete Photographer*, no. 6 (1941), pp. 335–38.

———. "It Has to Walk Alone." In *Photographers on Photography: A Critical Anthology*, edited by Nathan Lyons, pp. 15–16. Englewood Cliffs, N.J.: Prentice-Hall, 1966.

———. "Photography at the Crossroads." In *Photographers on Photography: A Critical Anthology*, edited by Nathan Lyons, pp. 17–22. Englewood Cliffs, N.J.: Prentice-Hall, 1966.

———. *The World of Atget*. New York: Horizon Press, 1964.

Borcoman, James. *Eugène Atget, 1857–1927*. Ottawa: National Gallery of Canada, 1984.

Cartier-Bresson, Anne. "Techniques d'analyse appliquées aux photographies d'Eugène Atget conservées dans les collections de la ville de Paris." In *ICOM Committee for Conservation, 8th Triennial Meeting, Sydney, Australia, 6–11 September, 1987*, pp. 106–10. Los Angeles: Getty Conservation Institute, 1987.

Colloque Atget. Proceedings of the conference, Collège de France, Paris, June 14–15, 1985. Paris: Association française pour la diffusion de la photographie, 1986.

Desmarais, Charles. "Julien Levy: Surrealist Author, Dealer, and Collector" *Afterimage* (January 1977), pp. 4–7, 20.

Hambourg, Maria Morris. "Atget, Precursor of Modern Documentary Photography." In *Observations. Essays on Documentary Photography*, edited by David Featherstone, pp. 25–39. Carmel, Calif.: The Friends of Photography, 1984.

Hambourg, Maria Morris, and Christopher Phillips. *The New Vision: Photography Between the World Wars*. New York: The Metropolitan Museum of Art, 1989.

Harris, David. *Eugène Atget: itinéraires parisiens*. Paris: Musée Carnavalet; New York: Museum of the City of New York, 1999.

Hill, Paul, and Thomas Cooper. "Man Ray" (interview). In *Dialogue with Photography*, pp. 17–25. New York: Farrar, Straus, and Giroux, 1979.

Krauss, Rosalind, and Jane Livingston. *L'Amour fou: Photography and Surrealism*. Washington, D.C.: The Corcoran Gallery of Art; New York: Abbeville, 1985.

Laxton, Susan. *Paris as Gameboard: Man Ray's Atgets*. New York: Miriam and Ira D. Wallach Art Gallery, Columbia University, 2002.

Lemagny, Jean Claude, et al. *Atget, le pionnier*. Paris: Marval, 2000.

Leroy, Jean. *Atget: magicien du vieux Paris en son époque*. 2d edition. Paris: P. J. Balbo, 1992.

Levy, Julien. Interview by Paul Cummings, May 30, 1975. Archives of American Art, Smithsonian Institution, Washington, D.C.

———. *Memoir of an Art Gallery*. New York: G. P. Putnam's Sons, 1977.

———. *Surrealism*. New York: Black Sun Press, 1936. Reprint, New York: Da Capo Press, 1995.

Michaels, Barbara. "An Introduction to the Dating and Organization of Eugène Atget's Photographs." *The Art Bulletin*, vol. 61 (September 1979), pp. 460–68.

Nesbit, Molly. *Atget's Seven Albums*. New Haven: Yale University Press, 1992.

Nesbit, Molly, and Françoise Reynaud. *Eugène Atget, Intérieurs parisiens: un album du musée Carnavalet*. Paris: Éditions Carré / Paris-Musées, 1992.

O'Neal, Hank. *Berenice Abbott, American Photographer*. New York: McGraw-Hill, 1982.

Phillips, Christopher, ed. *Photography in the Modern Era: European Documents and Critical Writings, 1913–1940*. New York: The Metropolitan Museum of Art / Aperture, 1989.

Photographs from the Julien Levy Collection. New York: The Witkin Gallery, 1977.

Reynaud, Françoise. *Eugène Atget*. Paris: Paris-Musées / Éditions du Patrimoine, 1985.

Sartre, Josiane. *Atget: Paris in Detail*. Translated by David Radzinowicz. Paris: Flammarion, 2002.

Schaffner, Ingrid, and Lisa Jacobs, eds. *Julien Levy: Portrait of an Art Gallery*. Cambridge, Mass.: MIT Press, 1998.

Solomon-Godeau, Abigail. "Canon Fodder: Authoring Eugène Atget." In *Photography at the Dock: Essays on Photographic History, Institutions, and Practices*, pp. 28–51. Media and Society 4. Minneapolis: University of Minnesota Press, 1991.

Szarkowski, John. *Atget*. New York: The Museum of Modern Art / Callaway, 2000.

———. *Looking at Photographs: 100 Pictures from the Collection of The Museum of Modern Art*. New York: The Museum of Modern Art, 1973.

———. *The Photographer's Eye*. New York: The Museum of Modern Art, 1966.

Szarkowski, John, and Maria Morris Hambourg. *The Work of Atget*. 4 volumes. New York: The Museum of Modern Art, 1981–85.

Travis, David. *Photographs from the Julien Levy Collection Starting with Atget*. Chicago: The Art Institute of Chicago, 1976.

Yochelson, Bonnie. *Berenice Abbott: Changing New York*. New York: The New Press / Museum of the City of New York, 1997.

Index

Photography Credits